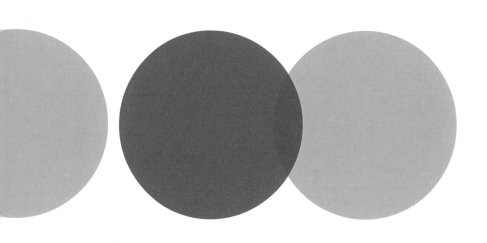

essays
on
design
13

디자이너가 일하는 규칙 125

우노 쇼헤이
외 9인
공저

김상미
옮김

design **house**

125

◆

디자인이나 크리에이티브한 일에 조금이라도 관여하고 있는 사람이라면 업무의 독특함과 재미, 심오함을 매일 맛보고 있을 것입니다. 또 어떤 직종, 어떤 위치에 있는 사람이든 때로는 고민하고 자문자답하며 프로젝트를 진행하고 있겠지요.

◆

이 책은 일하는 틈틈이 또는 출퇴근길에 읽기를 권합니다. 아트 디렉터, 프로듀서, 금융 컨설턴트, 패션 디자이너, 건축가, 조명 디자이너, 포토그래퍼, 플라워 데코레이터 등 크리에이티브한 업종의 최전선에서 활약 중인 10인의 전문가들이 말하는 업무 수행의 열쇠를 한자리에 모았습니다. 오랜 경험에서 우러난 의미심장한 조언들이 응축되어 있습니다.

◆

이 책은 정해진 순서나 분류가 없습니다. 마음에 드는 곳을 펼쳐 지금 여러분이 찾고 있는 말들과 만나십시오. 그 안에 담긴 지혜를 통해 지금 진행하고 있는 프로젝트의 실마리를 얻을 뿐 아니라, 나아가 무궁무진하고도 다양한 가능성을 찾을 수 있을 것입니다.

PROFILE

◆

일본을 대표하는
10인의
크리에이터

◆

아트 디렉터

우노 쇼헤이 SHOHEI UNO

1970년 도쿄도 출생. 1995년 니혼대학 대학원 이공학연구과 졸업 후 건설 컨설턴트·디자인사무소를 거쳐 SURMOMETER INC.를 설립. 토목·건축에서 패션, 음식에 이르기까지 다양한 장르와 매체에서 PR, 광고, 툴 기획, 서적 감수 등을 담당.《공예 그릇과 도구 SML》의 바이어·디렉터로도 활동하고 있다.

◆

편집자, 프로듀서

기타 유키히로 YUKIHIRO KITA

1972년 아이치현 출생. 문과 학부를 졸업한 후 출판사를 거쳐 프리랜서. 건축에서 음식까지 폭넓은 장르에서 기획과 프로듀서로 활동하고 있다.

◆

금융 컨설턴트

기무라 시게루 SHIGERU KIMURA

도쿄도 출생. 1989년 와세다대학 법학부 졸업 후 CI컨설팅회사(PAOS) 등을 거쳐 2000년 트랜지스터 설립(대표이사). 택지건물 거래 주임자, 주택 대출 어드바이저, 공인부동산 컨설팅마스터. 건축가의 파트너로, 디자인 마인드를 가진 부동산 컨설팅, 중개, 금융 어드바이스를 전문으로 활동하고 있다.

◆

패션디자이너

구니토키 마코토 MAKOTO MUNITOKI

1975년 군마현 출생. 2001년 무사시노미술대학 조형학부 공간연출디자인학과 패션코스 졸업. 세상에 단 하나뿐인 '보더 시리즈border series'가 특징인 패션브랜드 'STORE'를 운영. 무대의상 제작. 일본 각지에서 의복을 테마로 하는 워크숍과 전시회를 개최. 지역 밀착형 아트 프로젝트 'TERATOTERA'의 아트 디렉터 등 다채로운 활동을 전개하고 있다.

◆

건축가

구로사키 사토시 SATOSHI KUROSAKI

1970년 이시카와현 가나자와시 출생. 1994년 메이지대학 이공학부 건축학과 졸업 후 제조업, 설계사무소를 거쳐 2000년 APOLLO1급건축사사무소 설립(대표이사). 게이오기주쿠대학 대학원 이공학연구과 비상근강사. 주택과 상업건축을 중심으로 국내외에서 설계, 컨설턴트로 활동하고 있다. GOOD DESIGN AWARD, 도쿄건축상, 일본건축가협회우수건축선 등 다수 수상. 주요 저서로는 《새로운 주택 디자인 교과서》, 《아주 재미있는 집짓기 도감》(X-Knowledge), 《이상한 집》, 《꿈이 사는 집》(후타미쇼보) 등이 있다.

◆

조명 디자이너

도쓰네 히로히토 HIROHITO TOTSUNE

1975년생. 도쿄도 출신. 1997년 도쿄대학 공학부 건축과 졸업 후 라이팅 플래너 어소시에이츠(LPA)를 거쳐 2005년 시리우스 라이팅 오피스 설립. 건축·환경 조명, 도시설계에 이르기까지 풍부한 경험을 살려 다양한 장르에서 활동하고 있다. 도쿄스카이트리 등 일본 국내의 건축 조명은 물론 해외의 대형 건축 실적도 다수. 2013년 북미조명학회·조명디자이너 어워드에서 최우수상 수상.

◆

포토그래퍼

도리무라 코이치 KOICHI TORIMURA

1976년 치바현 출생. 1999년 메이지대학 이공학부 졸업 후 나카사 앤 파트너즈를 거쳐 2007년 도리무라 코이치 사진사무소 설립. 주택에서 상업건축, 공공시설까지 공간사진 촬영을 계속하고 있으며 건축가들의 신뢰도 두텁다.

◆

플라워 데코레이터

후지와라 사치코 SACHIO FIJIWARA

치바현 출생. 사립고등학교 졸업 후 후지TV에서 플라워 장식을 담당. 이후 주식회사 渚華-shoca-설립(대표이사). 꽃꽂이는 물론 조화, 크리스마스 오브제 등의 장식과 인테리어 스타일링 작업도 하고 있다.

◆

건축 디자인 전문 PR

무토 치카 CHIKA MUTO

무사시노미술대학 졸업 후 클라인 다이덤 건축사무소에서 홍보, 오피스 매니저, 이벤트 코디네이터 등을 담당. 2006년 건축가·디자이너를 대상으로 해외 커뮤니케이션과 PR 서포트를 주업무로 하는 neoplus610을 설립.

◆

STANDARD TRADE 대표

와타나베 켄이치로 KUNICHIRO WATANABE

1972년생. 요코하마 출신. 가나가와대학 건축학과 졸업 후 가구 제작을 시작하여 시나가와직업훈련학교를 졸업. 심플하면서 질 좋은 가구를 일반 주택에 공급하는 것을 목표로 1998년 STANDARD TRADE를 설립. 이후 오리지널 가구 디자인과 제조 판매는 물론 높은 기술과 공간 밸런스를 인정받아 주택, 오피스, 점포 등도 담당하고 있다. 다수의 유명한 가구의 수리·복원을 담당한 것으로도 높은 평가를 받고 있다.

첫
타자가
되라

Be the first
to get there

누군가의 뒤를 쫓지 말고 자신의 길을 열어 가는 사람이 되라. '정상'이라는 1등의 자리에 오르는 일은 어렵지만 '처음'이라는 1등의 자리에 서는 어렵지 않다. 최초가 된다는 것은 그만큼 돋보이는 일이다. '아무도 하지 않는다면 내가 한다'는 자세로 임하라.

1

番最初に
こだわろう

Don't be someone who just picks up the slack — be the guy who blazes the trail. You might not succeed in becoming the absolute top dog in your field, but you can be the "first" to get there. Just being the first to have tried something will make you stand out. Tell yourself, "I'll do it myself since nobody else will".

근거 없는
자신감을
가져라

Have groundless self-
confidence

결론이 뻔한 이야기를 마음먹고 해보자. 모두가 고개를 갸웃거려도 상관없다. 결론에 도달하는 과정을 생각하고 상황에 맞춰 그 길을 가면 그만이다.

Try saying something sweeping and conclusive once in a while. Who cares if you end up startling a few people? All you need to do then is to think about how you're going to reach that conclusion, and play the game according to the circumstances.

고르지 말고
뭐든지
맛보자

**Don't be picky-get a
taste of everything**

우연일까 아니면 필연일까. 갑자기 찾아온 기회에 어떻게 대처해야 할까? 'No, thank you'라는 자세로는 아무 일도 생기지 않는다. 디자이너는 직업이라기보다 삶의 방식에 가깝다. 하루하루 다양한 가치관을 접하고, 뭐든지 맛본다는 여유를 가져라. 비록 결과가 좋지 않더라도 모든 것은 하나의 커다란 디자인을 이루는 양분이 된다. 인생을 디자인한다는 생각을 가져라.

選び 好みせず
何でも味わおう

Do things happen by coincidence, or out of necessity? How should you tackle an opportunity that suddenly comes your way? Nothing will come out of a "no, thank you". Design is a way of life, rather than an occupation — they set out to make sure they have the time and freedom to sample a little bit of everything that life has to offer them, without being too picky. Even if the end result doesn't go the why you planned, just treat the whole process as a single, massive phase, just as if you'd intended to design your own life……．

주어진 시간에 맞춰라

Meet those deadlines

디자인은 제한된, 공평한 시간에 얼마 만큼의 성과를 내는가를 겨루는 창작 게임이다. 기발한 아이디어라도 제시간에 맞추지 못한다면 죽은 아이디어에 지나지 않는다. '시간이 좀 더 있었더라면'이라고 변명하는 디자이너가 있다면 절대 믿지 마라. 일에 임하는 기본 자세나 시간 관념은 그의 디자인에 확연히 드러난다.

Start ------> Fix

時間に 間に
合わせよう

Design is a sort of creative game where people compete to see how much of a lasting impact they can achieve within the same limited span of time. No matter how amazing your idea is, no points are awarded if you don't make it in time. You can't place too much good faith in staff who make excuses like "I would've been able to do it if I had more time". Your basic attitude towards work and sense of discipline show up very clearly in the designs you produce.

예산을 의심하라

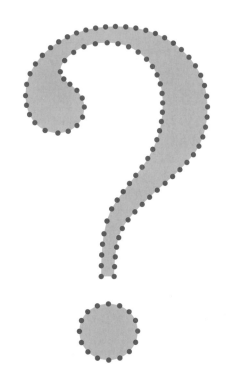

Be suspicious about
budgeting issues

'정말로 돈을 들여야 하는 일인가'에 대해 거듭 생각하라. 돈을 투자했
다고 해서 꼭 좋은 디자인이 나오는 것은 아니다. 오히려 반대의 경우
가 더 많다.

予算を疑え

Giving serious thought to whether you really need to spend money on
one thing or another is an essential aspect of design. You're not going
to end up with a good design just because you have the money — it's
actually the opposite.

세상의
흐름을
타라

Ride the waves that
are already
there

내가 만들어내는 흐름보다 이미 만들어진 세상의 흐름이 크고 빠르다. 처음부터 파도를 만들기 위해 체력을 소모하기보다는 이미 만들어진 파도를 잘 관찰하고 파악해라. 그리고 적당한 파도를 골라 흐름에 몸을 맡겨라. 그 속에서 나만의 흐름을 만드는 일은 보다 간단하다.

すでにある 波 に乗れ

The trends and currents that are already out there in the world flow much faster than anything you might create on your own. Rather than expending all that enough and getting all passionate about starting the next big thing on your own, study what's already out there, and separate the wheat from the chaff. It's easier to get into the game if you latch onto a wave and ride the current for a while before striking out on your own.

스텝 업業 하라

Step up

디자인을 업_業으로 삼았다면 먼저 사람들에게 보일 수 있는 실적을 쌓아라. 그리고 원하는 보수를 말할 수 있는 자신을 목표로 삼아라. 의뢰가 충분해지면 동료를 늘리고, 디자인 비용이 비싸더라도 나를 찾아오는 상황을 만들어라. 최종적으로 내가 하고 싶은 일을 선택하고, 나만의 시간을 가질 수 있게 된다면 그야말로 최상이 아닐까!

Once your design career has begun, work hard to make achievements that can be shown to others. Then pursue a status that allows you to offer your desired design fee. When you gain enough work, increase the size of your staff and aim for a status where clients offer you jobs for high fees. It would be wonderful to be able to choose work that you want to do, and to create free time at the end.

물고 늘어져라

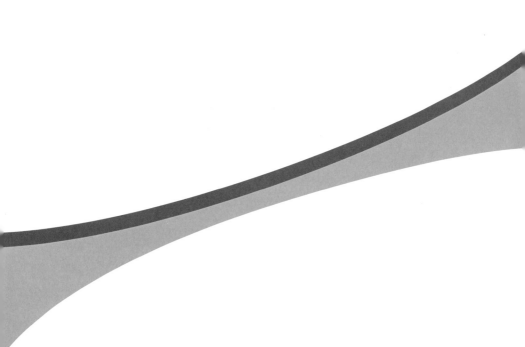

Stick with it

주어진 시간 안에서 끝까지 물고 늘어져라. 기나긴 과정 속에서 진정한 답과 만나게 되는 것은 마지막 한순간뿐. 그러니 잠시라도 긴장을 늦춰서는 안 된다. 끈질기게 물고 늘어져야 디자인은 완성된다. 디자인이란 물고 늘어지기다. 그러기 위해서는 체력이 필수적이다. 우리 회사에서는 "체력이 좋습니까?"라는 질문에 "체력이라면 자신 있습니다"라고 대답하는 사람만 채용한다.

粘れ

Persevere, persevere, and then persevere some more within a limited span of time. The real answer can be found only in a single moment at the very last stage of a long process, so you have to be sure not to slacken for even an instant. Designs come to completion by sticking hard and fast and not letting go. It's a demanding, physical operation. At my own firm, we only hire people who are confident about their own strength and physical health.

때로는 멀리
때로는 가까이

Look at your industry
both up close and from afar

업계의 상식이 일반 사회에서는 비상식으로 여겨지는 경우가 있다. 반대로 일반 상식이라 여겨온 것이 특정 업계에서는 비상식인 경우도 있다. 그러므로 항상 양쪽 면을 볼 수 있는 눈을 갖는 게 매우 중요하다. '만약 내가 제작자라면', '만일 내가 고객이라면' 하고, 상대방의 입장에서 생각할 수 있다면 조정 능력이 향상되어 순조롭게 진행되는 프로젝트가 늘어날 것이다.

業界を
遠 くで見たり
近 くで見たりしよう

What might pass for common knowledge in one industry sometimes doesn't apply at all to normal life. Similarly, even what one assumes to be common practice may not hold in certain specific contexts. Remember to always look at things from both these perspectives. By imagining yourself to be in the position of the creator, or the client, and going back and forth between these viewpoints, you'll be able to overlay one on top of the other and everything will work out well.

타깃을 정하라

Set a target

디자인은 예술과 달리 상대방에 맞춰 작업하는 일이다. 자신의 디자인 특징을 잘 이해하고 그 디자인에 가장 적합한 고객층을 타깃으로 삼는 일이 중요하다. 취향이 다른 고객과 일해보고 싶다면 디자인의 폭도 넓혀야 한다. 늘 전략을 준비하는 것은 비즈니스의 기본이다.

ターゲットを定めよう

Unlike art, a design is created depending on clients. It's important to be familiar with the characteristics of your design, and pursue client groups who most accept your designs. To work with other groups, diversification of your design range is required. Having a strategy is one of the basics of business.

성장 가능성을 보여라

Show your potential for growth

자기 색이 있다는 것은 나쁜 일이 아니지만 정체되기 쉽다. 반대로 필요한 색에 물들 수 있는 유연함은 가능성을 느끼게 한다. 젊은이에게는 경험이 없는 대신 성장 가능성이 있다. 성장 가능성, 즉 재능을 걸어보기로 결정하면, 선배는 손을 내밀고 고객은 의뢰를 검토할 것이다. 모른다는 사실을 두려워하지 말고 겸손히 배우고 성장 가능성을 보여라.

伸び代の可能性を示そう

Having a distinct, fixed quality to your work is not in itself a bad thing, but the room for growth in someone who's still inexperienced is much, much greater. In contrast there's lots of potential in a flexible attitude that can adapt as necessary. What young people lack in experience, they make up for in terms of potential. When juniors decide to develop this potential and talent, their seniors ought to step in and help, and clients should hire them for jobs. Don't be afraid of what you don't know, learn humbly, and make that potential flourish.

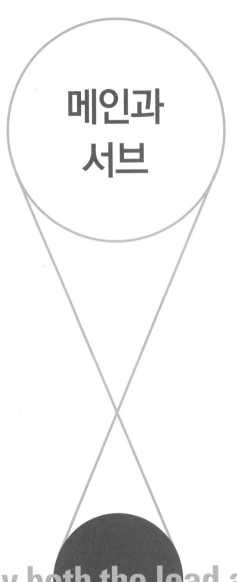

메인과
서브

Play both the lead and
supporting roles

자신의 역할을 프로젝트의 성격에 따라 바꿔보자. 객관성을 얻을 수 있다. 그러기 위해서는 여러 장르의 프로젝트를 다양한 사람들과 수행해볼 필요가 있다. 같은 사람과 정해진 일만 한다면 변화와 확장, 유연한 발상을 하기 힘들다. 메인과 서브, 두 가지 역할이 가능할 때 비로소 당신은 진정한 전문가다.

You learn to become more objective by assuming different roles depending on the project. In order to pull this off, you need to work with lots of people on all sorts of different projects. If you only work on set projects with the same group of people, you're not going to gain breadth, accomplish change, or get a more flexible and versatile handle on things. The ultimate goal is to become able to play both the main role and the supporting one.

무엇을
기대하는가?

Think about what's
expected of you

고객이 디자인을 의뢰할 때, 자기 색이 분명한 베테랑 디자이너에게는 그의 색깔에 맞는 결과물을 기대하는 경우가 많다. 반대로 경험이 없는 디자이너라면 어떨까? 그땐 고객이 자신에게 무엇을 기대하고 있는지 생각해봐야 한다. 저돌성, 모험심 혹은 새로운 감각. 이것을 바탕으로 디자인을 한다면 쓸데없는 시간과 노력의 낭비를 줄일 수 있다.

期待されていることを考えよう

When veteran designers accept commissions for work, clients often expect results that mirror the style or idiom that those designers have become known for. What about designers with no experience, though? Maybe designers should also think hard about what's expected of them — is it energy, unpredictability, or freshness? Just by going about your work with this in mind, you might be able to rid yourself of time-wasting, unproductive exchanges.

가치의
적소適所를
생각하라

Consider
where
the
value
exists

고객이 지불하는 디자인 비용이 무엇에 대한 대가인지 생각해보라. 노동력? 브랜드? 아이디어? 멋진 비주얼? 상대가 인정하는 가치와 내가 원하는 가치가 어긋나 있다면 언젠가는 삐걱거리게 마련이다. 반대의 경우라면 물론 서로의 비즈니스 성과를 극대화할 수 있을 것이다.

の居場所を考えよう

Think about what the client pays for with the design fee, such as labor, brands, ideas, or beautiful visuals. If there is a gap between the values that the client recognizes and the values you want to pursue, the relationship will be distorted at some point. Conversely, if your values match, you should be able to maximize each other's business.

양量을
늘려서

질質을
높여라

**Boost quality by
increasing volume**

질량전화質量轉化의 법칙. 다양한 성격의 프로젝트를 동시에 수행하면 디자인 창의력이 비약적으로 확장된다. 직선적으로, 우회적으로, 때로는 되돌아가는 과정을 통해 경험이 쌓이고 높은 산도 오를 수 있게 된다. 어떤 프로젝트에 도움이 되는 실마리가 다른 프로젝트에 숨어 있는 경우도 많다. 얼핏 쓸모 없어 보이는 일 속에 문제 해결의 실마리가 있기도 하고, 멀리 돌아가는 중에 새로운 풍경을 만나기도 한다. 저글링처럼 여러 개가 동시에 움직이는 다이내믹한 상황, 그것이 바로 새로움이 탄생하는 최적의 환경이다.

量をこなし
質を上げよう

volume

quality

Big masses tend to undergo a transformation. By pursuing all sorts of varied projects at the same time, your design creativity is going to expand dramatically. Over the course of trying direct, head-on approaches, making detours, or retracing your steps, you accumulate experience and become able to tackle even the most daunting obstacles. The key to one project is often hidden within another. Hints to solving a particular problem and sometimes lie precisely within something that seems utterly useless. Going around in circles and taking the long way around can reveal an new vista. The dynamism to be found in many parts being activated at the same time, just like juggling, is the best situation in terms of making new discoveries.

방향이 다른
조언이라도
시도하라

**Try it and see,
even if someone tells
you otherwise**

선배로부터 업무와 처리 방법까지 지시를 받아 진행하고 있는데 다른 선배가 더 좋은 방법이 있다며 다른 방식을 조언한다. 서로 다른 두 가지 조언으로 다소 난처한 상황…. 오른쪽으로 가라면 오른쪽으로, 왼쪽으로 가라면 왼쪽으로 갈 수밖에 없는 입장일 때가 있다. 일의 양은 두 배가 되겠지만 시간을 쪼개 양쪽 모두를 진행해보자. 어쨌든 두 가지 방법을 손에 넣는 셈이니까. 이렇게 생각해보는 것도 나쁘지 않을 것이다.

異なる

アドバイス

があっても試してみよう

So one of your seniors gives you instructions, and even shows you how to get something done, When you do as you've been told, though, someone else tells you that it should be done his way, which confuses you. You need to take a position, and choose if you're going to take your cue from your left or your right. Maybe it's going to take you twice the time and effort, but suck it up and get on with your work as efficiently as you can. Ultimately, you're going to learn two ways of getting things done, so just go for it. You could do a lot worse.

같은 방향을 바라보라

**Keep your eyes trained
on the same target**

클라이언트와 디자이너는 무의식적으로 서로를 바라보고 기분을 살피면서 흥정하기 쉽다. 발상을 바꿔 서로를 바라보는 것이 아니라 같은 방향을 바라보자. 같은 곳을 향해 함께 가고 있다는 '느낌'을 갖게 된다면 최고의 상황! 클라이언트는 더 이상 적이 아닌 동지가 된다.

Designers and clients tend to be too uptight when they meet, haggling with each other while trying to figure out what the other is thinking. Instead of being so high-strung and confrontational, let's try seeing eye to eye, and look in the same direction. Once it feels as if we're headed in the same destination, it's a done deal. Don't think of your client as your enemy, but as someone on your own team.

계약의 흐름으로
위험을 파악하라

**Use the contract-signing
process to measure the risk**

일을 진행할 때 계약을 맺지 않는 클라이언트는 기본적으로 당신을 믿지 않거나 속이려는 심산이다. 진심으로 의뢰할 생각이 있다면 계약을 망설일 이유가 없을 테니까. 계약하겠다는 말만 하고 실제로 진척이 없는 것 또한 위험 신호. 디자인은 서로의 신용을 토대로 성립하는 것이 절대 조건이다. 일하던 손을 즉시 멈추고 상대를 견제하라. 때로는 작업에서 손을 떼는 용기를 가져라. 계약하지 않았다는 것은 나 또한 자유라는 의미니까.

契約
の流れで
危!険性
を測ろう

Basically, if a client does not sign a contract, they do not trust you or they are trying to deceive you. If they truly intended to offer you a job, no obstruction should exist to signing a contract. It is a danger sign when the client agrees to make a contract but the contract process does not proceed smoothly. An absolute requirement for design is the establishment of a mutual-trust relationship. Stop immediately and warn the client. Sometimes having the courage to walk away is required. Having no contract means you are also free.

나를
이해하는 사람을
늘려가라

Get to know
more people who
understand you

원하는 일을 하고 싶다면 한 사람씩 나를 이해하는 사람을 늘려가라. 먼저 마음을 전하고, 생각을 말하고, 가치를 보여줘라. 그리고 누구보다도 그 일에 애정을 가지고 있으며, 뛰어나다는 것을 증명하라. 혼자서 할 수 있는 일은 제한적이다. 상사와 동료, 클라이언트와 비전을 공유하라. 공통의 목표를 가지고, 목표를 향해 달려갈 마음이 있다면 좋은 결과가 따라오는 것은 당연한 법이다.

理解者を

増やしていこう

If you want to do the jobs you want, start by getting to know people who understand what you're about, one by one. More than anything else, you need to communicate what you're thinking, describe your thought processes, demonstrate what you mean — and prove that nobody has a greater passion and knowledge than you do for the subject in question. There's a limit to what a single person can do. Share your dreams with your boss, colleagues, and clients. When you share common objectives and have a frame of mind that will lead you to accomplish them that, the things you'll be capable of are going to increase dramatically.

타이밍!
　타이밍!
타이밍!

Timing is everything

좋은 디자인을 주목받게 하는 열쇠는 타이밍을 잡는 일에 있다. 홍보가
효과를 발휘하는 것은 한순간이다. 아무리 좋은 사진, 유익한 정보라도
뉴스거리가 되는 타이밍에 홍보하지 않는다면 아무런 의미가 없다.

タイミング》

《がすべて

》

The key to getting a good piece of design noticed has everything to
do with the right timing. Even an effective PR campaign only works
for an extremely brief window of time. No matter how amazing your
photography, diagrams, and other materials are, they won't mean
anything unless you get your PR out there while it's still fresh and can
make a good news item.

누구를 위해
일하고
있는가

Don't forget
who you're
working for

누구를 위해 무슨 일을 하고 있는가를 명확히 인식하는 일은 직접적이
면서도 심플한 원동력이 된다. 내가 제공하는 서비스가 누군가의 미래
에, 어떤 영향을 미칠지 생각하면서 작업하라.

A clear idea of who or what you're working for is a direct and simple
source of motivation. Make sure you keep in mind whose future the
service you're providing is helping to build, and how it's going to create
that impact.

금붕어 똥

Shadow people

평소에는 한걸음 뒤에서 선배의 체면을 세우고, 때로는 한걸음 앞에서 준비하라. 금붕어 똥처럼 같은 선배를 늘 따라다니면 일하는 방법을 배울 수 있다. 그 방법은 스스로 생각하는 것보다 훨씬 빠르니까 딱 붙어 따라다니도록!

金魚のフンでもいい

Walk just behind your superiors to flatter them and make them feel good, but once in a while, stay one step ahead of them to make sure things are ready. You'll remember how to get things done if you keep shadowing the same superior. Cling to them like a leech — it's much faster than trying to work it out yourself.

만나고 싶은
사람을
만나러 가라

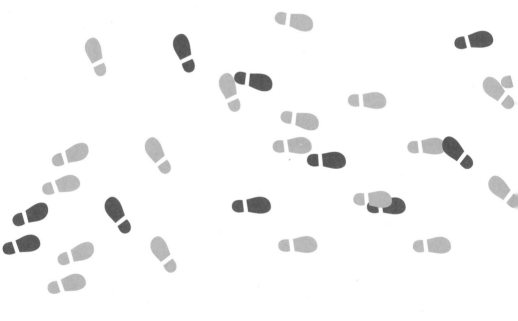

Go meet the people
you've always
wanted to

영업을 처음 시작했을 때는 우왕좌왕. 업계 관행도 모른 채 일하는 모습을 보고 싶다는 이유만으로 영업 상대를 찾아갔다. 무사태평한 이유로 찾아온 내가 얼마나 귀찮았을까. 하지만 보고 싶다는 욕구는 일의 근원이 된다는 사실을 잊지 말기를.

会いたい人に
会いに行こう

When you just got started in this business, you didn't know your left from your right, and had no idea how the industry worked. The only thing you could use to situate or contextualize the person you were working with was the job itself. That sort of innocent, carefree motivation might have been something of a nuisance for all involved, but the desire to see things and go places is something that you should cherish as the basis of your work.

다양한 선택지를
제시하라

Provide lots of options

비교 검토가 가능한 자료를 제시하는 일. 머릿속에 있는 프로세스를 보여주는 일. 이러한 과정을 통해 독단적인 작업이 되지 않도록 주의하라. 현장 사진을 예로 들어보자. 디지털 기술의 발달로 사진 촬영이 손쉬워졌다. 시간과 공간이 제한적일지라도 다양한 앵글로 촬영한 자료를 제공할 수 있도록 하라.

Be careful that the finished product doesn't become something dogmatic and unilaterally decided on by providing your collaborators with materials that they can weigh against each other, and making clear how your own thinking process developed. Even now, when digital formats have become the norm for photography, you can still shoot from multiple angles even with limited time and space at the given location.

WHEN WHERE WHAT WHY WHO

뭐든지 물어라

HOW

WHEN WHERE WHAT WHY WHO

WHEN WHERE WHAT WHY WHO

WHEN HOW WHERE WHAT WHY WHO

HOW

WHEN WHERE WHAT WHY WHO

HOW

WHEN WHERE WHERE WHY WHY WHO W

WHAT WHAT

HOW

WHERE HOW HOW WHEN

WHAT

Ask anything

WHY WHO

HOW

먼저 자신이 대면해야 할 디자인에 대한 지식을 쌓아라. 모르는 것이 생기면 선배, 동료, 현장 작업자에게 물어보고 배울 것. 누구나 "젊은 시절에 당하는 창피는 부끄러움이 아니다"라고 곧잘 말하지만 실제로 모르는 것을 솔직히 물을 수 있는 사람은 드물다. 정직하게 질문할 수 있는 것도 '재능'이다. 그렇게 오랫동안 쌓아 나간 지식은 당신을 배신하지 않는다.

何でも質問しよう

WHEN WHERE WHAT WHY WHO HOW

First, you need to store knowledge about the designs you will be working on. If you are confused, ask any question to your predecessors, business partners, or workers at a production site, and learn practically. It's often said, "shame in your youth is not shame", but only a few people can actually be honest and ask about what they don't know. The ability to immediately ask is a "Talent". The knowledge acquired through taking the time won't disappoint you.

기분 좋게 행동하라

Always be in a good
mood

뛰어난 크리에이터 중에 불쾌한 얼굴을 하고 있는 사람은 없다. 디자인의 비밀을 알고 있는, 진정한 크리에이터는 진정한 전달자이기도 하다. 고뇌를 죄다 짊어진 것 같은 크리에이터의 불쾌한 행동은 자신 없음의 반증인 경우가 많다.

ご機嫌に
振る舞おう

I don't know any top creators who go around with a long face all the time. Designers who have a real grasp of the tricks of their trade are real communicators. A sullen face that carries the weight of its troubles on its own shoulders is often just the flip side of a lack of self-confidence.

새가슴이
나쁜 것만은 아니다

Stay timid

어디까지나 사람을 상대하는 일. 겁이 많은 성격은 신중함과 공손함을 낳는다. 고로 겁이 많다는 것은 상대방에게 이득이 된다.

気

の小ささを
もとう

We're dealing with people here — being timid helps you to become prudent and discreet, and is beneficial for the other person as well.

작은 일부터
하나씩 하나씩

Peck away steadily at
the small stuff

확실하고 정성스럽게 일하라. 거르지 않고 물을 주어야 씨앗은 아름다운 꽃을 피운다. 이러한 과정은 보는 이에게 감동을 주어 '또 보고 싶다', '이 사람 밑에서 성장하고 싶다', '일을 맡기고 싶다'라는 마음을 불러일으킨다.

小さなことからコツコツと

Careful, diligent, and steady work pays off. Beautiful flowers bloom when plants are watered and cared for every single day. People who see your work will be impressed, come back for more, hire you back again, or want to come under your wing.

좋은 분위기를
만들라

Keep the atmosphere
comfortable

좋은 영향이든 나쁜 영향이든 현장에 있는 사람이 작업 결과에 영향을 미치는 경우가 있다. 우리 쪽에서 먼저 좋은 분위기를 만들도록 노력하라.

いい
を
つくろう

The people who are present sometimes influence results — in a good or bad way. Make an effort to create a comfortable atmosphere early on.

어려운 상대에게
상담하라

**Sound out people you
don't really click with**

막다른 국면에 봉착했을 때 비슷한 생각을 가진 사람이나 사이가 좋은 선배에게 상담을 하면 예상대로의, 무난한 답이 돌아온다. 안심은 되겠지만 상상의 범주 안에서 일을 하다 맞이한 상황을 해결할 방법이 되지 못하는 경우가 대부분이다. 자신의 능력을 넘어선 일이라면 눈 딱 감고 평소에 어렵게 생각하던 상대에게 상담해보라. 정반대의 신선한 의견을 듣게 될지도 모른다.

If you discuss things with people who think like you do, or with superiors that you have a good relationship with when you're stuck, you're going to get answers and advice that you anticipated anyway. You ran up against a wall while engaged in something that didn't exceed the scope of your own imagination, so this approach doesn't usually lead anywhere. This is a problem that's too much to handle by yourself, so take a risk and ask someone that you might not be completely comfortable with. You might actually hear a new perspective on your plight.

잡담으로
원하는 것을
알아내라

Determine what the
client wants
through small talk

구체적인 아이디어 없이 디자이너를 찾는 고객이 많다. 아이디어를 구체화할 시간이 없거나 전적으로 디자이너에게 의지하는 경우다. 그러면서도 결과물에 대해서는 이런저런 불평을 쏟아내 좀처럼 끝이 보이지 않는다. 종종 벌어지는 이런 일은 친밀한 커뮤니케이션으로 어느 정도 예방이 가능하다. 잡담을 나누면서 상대방의 취미나 기호를 파악하라.

無駄話で
要望を
聞き出そう

Clients often commission work from designers before they have a concrete idea of what they want or need. Sometimes they don't have the time to spend on the project, while other times they just trust the designer to do what's best — before coming back to nitpick and find fault with what you've come up with. This results in a poor idea of what the final product should be. This situation is extremely common, but thorough communication between the two parties can help to prevent it. Try to suss out your client's tasted and preferences by making small talk with him.

때로는
클린치

Clinch

어쩔 수 없는 상황이라면 결말을 지어라. 멋진 스트레이트 펀치 한 방이 말처럼 쉬운 일은 아니다. 잽, 잽, 가드, 잽, 가드. 언제나 자신의 페이스로 갈 수만은 없는 일이니까.

クリンチ しよう

Try clinching if it looks like you aren't going to get anywhere. A clean, straight punch rarely gets the job done. Jab, jab, guard, jab, guard. This doesn't just apply to your own pace.

자신의 상황을
똑바로
파악하라

Size yourself up
accurately

완만한 내리막이 존재한다는 사실을 잊어서는 안 된다. 나아지지 않고
손쓸 길이 없다면, 그것은 그 자리에 머물러 있는 것이 아니라 천천히
내려가는 중이다. 정체는 퇴보와 같다. 그 자리에 머물러 있는 일조차
용납해서는 안 된다.

自分の状況を
正しく
把握しよう

There are no flat and even paths you can take when it comes to work.
But are you going to notice when the terrain starts to slope downwards
ever so slightly? Without realizing that you've quietly started to slide
downhill, you find yourself with the mistaken impression that you're
still at a point where you're not making any progress. Nope, you're
actually starting to regress, my friend. Pay attention if you're slipping,
no matter how gentle the gradient might be. You'll be going upwards
the next time around.

너 자신을 알라

Know yourself

스포츠와 마찬가지로 자신의 강점과 약점을 자각하는 일이 중요하다. 디자인의 경우 특징이 확실하지 않으면 좋은 작업물로 인정받기 어렵다. 의도적으로 자신의 강점을 부각시켜서라도 '모난 돌'이 되게 하라. 모난 돌이 정 맞는 일은 없다. 기회가 될 것이다. 그리고 두려워 말고 일관되게 할 수 있는 일을 하면 된다.

pile

己を知るべし

Life in sports, it's important to know your strengths and limitations. For designing, work won't be accomplished without clear characteristics; therefore, emphasize your strengths, purposely or not, and be a "stake that sticks out". The stake sticking out won't be beaten but grabs an opportunity. Then do what you can do, both fearlessly and firmly.

상대방이 지닌
신선함을
공유하라

Tap the freshness of
your collaborators

당신에게는 반복적인 일일지라도 상대방에게는 신선할 수 있다는 것을 잊지 말아라. 횡단적이고 연속적인 작업에서 얻은 지식과 발견을 아끼지 말고 제공하라. 공유를 통해 새로운 발견을 하게 될지도 모른다.

相手が持ってる
新鮮さを
共有しよう

Don't forget that your collaborators are always going to have something new and fresh to bring to the table, even if you've done this a thousand times. Bearing this in mind, make sure to generously offer them the knowledge and discoveries that you've acquired over the course of your genre-crossing career. In the same way, you might make some other discoveries by sharing this sense of freshness.

리셋
버튼을
눌러라

Hit the reset button
and move on to
the next thing

클라이언트의 수만큼 다양한 종류의 작업이 있다. 한 작업을 끝내고 다음 작업을 시작할 때는 지금까지의 경험을 리셋하고 새로운 기분으로 맞이하라. 성공한 경험을 쌓다 보면 주관에 빠지기 쉽다. 아무리 훌륭한 경험이라 할지라도 안일하게 대응하지 마라. 크리에이티브한 작업을 하는 데 있어 중요한 것은 중립을 유지하는 일이다.

Every single client you deal with is going to entail a different set of project specifications. If that's the case, you should hit the reset button on all your previous experience when one job ends and you proceed to tackle the next one, approaching it with a fresh mind. The reason is that you tend to become a parody of your own style if you rack up too many successes. In creative fields, what matters is doing the necessary preparation to ensure that you approach each assignment with a neutral stance, without drawing too readily from previous experiences, no matter how amazing they may have been.

조언을 구하러
오게 하라

Become someone
that people
talk about

그 분야의 전문가로 인식될 수 있도록 노력하라. "○○라면 ○○씨예요" 라고 할 정도로, 업계 내에 특징적인 분야나 위치를 만들어라. 이런 식으로 인식되기 시작하면 미디어의 관심을 저절로 받고 노출의 기회도 늘어난다.

コメントを

求められる

存在になる

Recognition will come if you're an expert in a particular field. Establish a unique, niche position so that people will automatically associate your name with a specific set of skills or expertise. Once people know about you, media coverage will naturally follow, and your exposure will increase.

넘버원
작업을
경험하라

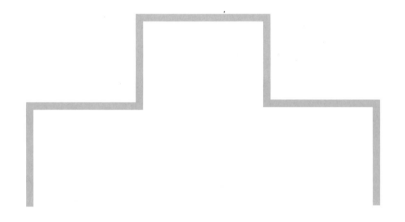

Get experience
with top
players in
their own field

아무리 작은 분야라도 좋다. 그 분야에서 '넘버원'으로 인정받을 수 있는 작업을 경험하라. '넘버원 작업'에는 공통적으로 특별한 무언가가 있다. 아무리 작은 분야라도, 한 번 그 분위기를 충분히 경험하면 다른 모든 작업에 응용할 수 있는 기준이 생기기 때문이다.

It doesn't matter how small a job at a place that ranks Korea. There's bound to be where only the best people your own work. Once you of that place, no matter how the field may be. Try doing among the top in all of something there — a job are — that overlaps with get a good taste of the vibe small the field might be, that experience will become a kind of benchmark that you can apply to all of your own projects, and stay with you forever.

젊음과 체력을
활용하라

Make full use of youth
and stamina

젊기 때문에 아직 시간이 많다고 생각한다면 오산이다. 젊다는 이유로
배울 수 있는 것도 잠시뿐, 후배가 생기기 시작하면 어느새 가르쳐야
하는 입장이 된다. 체력이 남아 있다는 것은 아직 배워야 할 일이 남아
있다는 뜻이다. 체력이 소진될 때까지, 하루하루 필사적으로 노력하라.
바로 지금, 이 순간이 가장 노력할 수 있는 때라는 사실을 잊지 말라.

若さと体力
を活かそう

There is plenty of time when you are young — this is a ridiculous lie.
You are only attentively taught when you're young, and when you
have younger designers you are placed in a position to teach. Having
stamina means having plenty to learn. Keep trying hard every day until
all of your stamina is gone. Now is the best time to try hard.

열정과
이상의

적절한
균형을
유지하라

Make both passion and
theory work for you

이론 없는 열정은 의미를 갖지 못하고, 열정 없는 이론은 공감을 얻지 못한다. 열정은 중요한 요소지만 열정만으로는 타인의 납득과 협력을 얻을 수 없고, 이론만으로 무장한 열정 없는 작업은 타인을 감동시킬 수 없다.

Pure passion without theory isn't going to get you anywhere. Pure theory without passion isn't going to get your message across. Passion is more important than anything else, but you won't be able to get to do jobs that involve other people. Projects that only emphasize theory but are drained of passion, on the other hand, are not going to be able to move people into action.

'표절'이 아닌 '오마주'

Don't rip off others, pay them a tribute

디자이너는 어떻게 해서든 타인과 다른, 세상에 존재하지 않는 것을 만들려 한다. 이것은 글자 그대로 본말전도本末転倒. 고객이 원하는 성과를 내는 일이 목적이어야 하는데 새로운 것을 만드는 일이 목적이 되는 꼴이다. 좋은 것은 누가 봐도 좋은 것이다. 결과적으로 닮았다 하더라도 그것은 분명 존경의 마음이자 경의의 표시다. 인간은 타인을 흉내 내며 배우고 성장해가는 것이다.

「バクリ」ではなく
「オマージュ」を

What makes designers different from other people is how they try to create things that don't already exist. So sometimes we tend to put the cart before the horse, thinking that the objective is to create something new, when what we should be doing is delivering the result that the client wants. The quality of a good product is self-evident. Even if a certain product ends up resembling something else, there's no doubt that it was conceived with the utmost respect for the original. People learn and develop by imitating others.

흉내는
콘셉트만!

When you copy,
copy concepts

다른 디자이너가 남긴 뛰어난 작업의 외형이나 형태를 흉내 내서는 안
된다. 오리지널을 뛰어넘을 수 없기 때문이다. 다만 디자인의 배경에
있는 콘셉트를 흉내 내는 일은 유효하다. 콘셉트를 이해해고 그것을
통해 생각하는 법을 배운다면 자신의 독창성을 실어 다른 차원의, 새
로운 표현이 가능하기 때문이다.

真似るなら
コンセプトを
真似よ

Do not copy appearances or shapes from other designers' fine works.
It's impossible to exceed the original work. However, copying the
concept that lies behind the design is effective. By understanding its
concept and learning the designer's way of thinking from it, you will be
able to add your originality and present a new expression.

적절한
아웃소싱을
하라

**Outsource things that
you can't do yourself**

적은 인원으로 회사를 운영할 때는 모든 작업을 직접 처리하려 하지 마라. 직원에게 익숙하지 않은 일을 시키는 것보다는 언제든지 믿고 맡길 수 있는 외부 전문 팀을 두는 것이 효율적이다. 보다 빠르게 완성도 높은 결과를 낼 수 있다.

You won't be able do everything in-house if you're running a compact firm with a small team on staff. Rather than making your staff handle tasks that they're unfamiliar with, being able to draw on the resources of a professional team outside your firm will enable you to deliver high-quality work at short notice.

팬,
팬,
팬을
늘려라

Increase
your
fan base

요즘은 "저는 이런 일도 저런 일도 할 수 있습니다!"라는 말보다 "저 사람은 이런 일도 저런 일도 할 수 있대"라는 말이 신뢰성을 갖는다. 사실 평가란 스스로가 아닌 타인이 하는 것. 그렇다면 이제 당신은 알아서 PR을 해줄 팬을 만들어야 한다. 물론 당신을 홍보해줄 사람을 PR하는 일도 잊지 마라.

Self-advertising your manifold talents and skills has now become less credible than other people spreading the word around on your behalf. Your reputation is not self-made — it's based on how others evaluate your work. This means that you should try to build a wide fan base that will automatically do your PR for you. Of course, don't forget to return the favor to these folks.

Hold on to your own
sense of value

가치를
만들어가는
존재가 되자

'영향은 받는 것이 아니라 끼치는 것이다'라는 아티스트 모리무라 야스마사森村泰昌의 말. '뭐든지 가능하다'는 것은 결국 '아무것도 가능하지 않다'는 것을 의미한다. 모든 가치가 동일해지고 모든 행위가 허락되는 상황에서 과연 무엇을 제시해야 하는가. 당신이 가치 있는 세상을 원한다면 고민해야 할 문제다. 새로운 가치를 만들어가기 위해서는 어느 지점에 도달했을 때 커다란 의식의 전환이 필요하다.

The artist Yasumasa Morimura once said that "influence is not something you are subject to, but rather something you exert." If anything goes, then nothing has any impact or significance. In a world where all values have become flat and anything is permitted, what are you going to "risk" choosing? That's the task demanded of those who've taken it upon themselves to question the values of this world. In order to create new values. you're going to need a major shift in consciousness at some point.

상대의
뇌리에
이미지를
남겨라

**Construct an image
in themind
of the viewer**

좋은 프레젠테이션은 상대방의 뇌리에 재빨리 이미지를 만들고 잔상을 또렷이 남긴다. 언어나 그림을 구사해 상대방의 뇌 속에 이미지나 아이디어를 선명하게 그려 넣는다. 그것의 해상도가 높으면 높을수록 공감이 쌓이고 신뢰 관계가 견고해진다. 반대로 직원조차 공감하지 못한다면 상대방의 뇌리에 남는 일도 없을 테니 소개할 필요조차 없다. 누군가의 뇌리에 잔상을 남기는 일은 디자인의 첫 번째 스텝이다.

脳髄にイメージを建築せよ

A good presentation creates momentary images in the mind of the viewer, leaving a clear and sharp imprint. You can trace images and ideas vividly in the mind of the other person using words and pictures. The higher the resolution of those images, the more sympathy you'll be able to elicit, and the more solid your relationship will become. Conversely, things that can't even strike a chord with your own staff are obviously not going to resonate with other people — not at all the sort of work you'd unleash on the world, is it? If you manage to leave an imprint on someone's mind, you've nailed the first step of the design process.

보기 좋게 마무리하라

Wrap up the job with flair

작업이 막바지에 이르면 클라이언트와 함께 지금까지의 과정을 되돌아보는 시간을 가져라. 그 과정을 통해 디자인은 진정으로 완성된다. 디자인에 대해 변함없는 애착을 갖도록 만드는 일이 디자이너가 해야 하는 마지막 최대의 작업이다. 그리고 현장에 디자이너의 흔적을 필요 이상으로 남기지 않는 일 또한 중요하다. 보기 좋게 마무리하고 다음을 향해 가라.

At the very last stage of a project, create opportunities to look back on the design process together with your client. This takes the design to its real conclusion. The designer's final — and most daunting — task is to make sure the client takes the effort to continue to develop an emotional attachment to the design. It's also important to ensure that the designer doesn't leave his or her mark on the site.

자신의 시간에 높은 가치를 부여하라

Set a high value for your own time

히트상품 하나로 대박이 나는 장사와 달리 의뢰를 받아 일하는 디자인은 시간이 자산이다. 할애할 시간이 없다면 의뢰도 받을 수 없다. 게다가 같은 작업을 반복하는 경우도 없어 매번 새로운 아이디어를 생각해내야 하는 비효율적인 일이다. 자신의 시간에 높은 가치를 부여하기 위해서는 짧은 시간에 높은 가치의 디자인을 고안해내는 수밖에 없다. 이 한 가지에 집중하라.

Unlike businesses that create limitless revenue when something makes a big hit, your time is the only resource for the design contract work. You cannot accept an offer when your available time is exceeded. Furthermore, since the same work is never offered twice, designing is an inefficient process because you must create a new design every time. The only way to set a high price for your time is to create a design with high value in a short amount of time. Concentrate on that.

언어 감각을 키워라

Hone a language that is your own

타인에게 자신의 생각을 이해시키기 위해 언제 어떻게 말해야 할지 항상 준비하라. 사물의 감각을 잡아내는 능력을 가진 사람은 어휘 선택에도 센스가 있다. 정확히 표현하지 못하는 사람에게 좋은 디자인도 기대할 수 없다. 평소에 디자인의 장점을 말로 설명할 수 있도록 어휘력을 키워라. 여러 사람에게 무형無形의 매력을 전달하기 위해 크리에이터가 해야 할 노력이다.

自身の言葉
をもとう

Always prepare yourself to know in advance which words you're going to use in relation to which point, so that other people can understand how you think. People who are good at reading and latching onto the sensations associated with certain things also have a delicate touch when it comes to language. Good design tends to be beyond the reach of inarticulate people. Work on acquiring a vocabulary that allows you to always explain verbally why something is good. This is the effort that the supplier needs to make, so that as many people as possible understand the intangible appeal of one design compared to another.

책임자가
없는 날을
만들어라

Make time
for days when
the boss
isn't around

상사가 지시를 할 수 없는 상황도 있다. 그럴 때는 임기응변으로 대처해야 한다. 지시 라인에 문제가 생겼을 때 대처하는 능력이 곧 조직의 진정한 역량이다. 가끔씩 의도적으로 상사의 공백 상태를 만들어 보라. 평소에 중간관리자를 임의의 최고책임자로 가정해 역량을 시험하는 일은 중요하다.

 不在の日をつくろう

There are not precise instructions from a boss, and each person must always think for adaptation to circumstances in such case. The true ability of the organization is reflected on movement when instructions system does not exist. I will occasionally make a state of the boss absence daringly. I put middle management in the temporary boss position, and it is important that I try an ability.

잔상 속의
작은 점을 찾아내라

Look for the little black
dots in the afterimage

공장 아주머니가 미동도 하지 않은 채 무언가를 주시하고 있다. 눈앞에는 벨트컨베이어 위의 자동차 엠블럼이 굉장한 속도로 줄줄이 지나간다. 아주머니는 엠블럼에 난 흠집이나 이물질을 발견하면 닦아내는, 불량품 점검을 하는 중이다. 아주머니는 하나하나를 보고 있는 것이 아니라 잔상 속의 작은 이물질을 가려낸다. 같은 일을 반복하다 보면 작은 문제점이 더욱 잘 보인다. '평소와는 다르네?'라는 느낌, 그 느낌이 중요하다.

残像のなかに
小さな黒い点を見つけよう

The lady who works in the factory looks straight ahead without moving her face one bit. The endless rows of car emblems on the conveyor belt whiz past her at an incredible speed. It's her job to find defective emblems on the conveyor belt whiz past her at an incredible speed. It's her job to find defective emblems with scratches or stains on them, and pull them from the belt right away. But she doesn't do the job by looking at the emblems one by one — what she's really doing is staring past them, at the little irregularities in the afterimage of all those objects. By doing this repeatedly, she becomes able to detect all the small problems. Different from the usual — this is important.

완전 붕괴가
아니라면
괜찮아

We're fine
as long as we don't
completely collapse

디자인 회사는 잔업이나 철야가 다반사. 꿈과 희망을 가슴에 품고 입사했지만 현실의 혹독함을 견디지 못해 그만두는 사람이 많은 것도 이 분야의 특징이다. 보다 좋은 회사가 되기 위해서 노동환경을 개선하는 것도 방법이겠지만 구인求人이 많은 것 또한 이 분야 나름의 방식. 그렇다면 '그만두는 사람이 있더라도 조직이 붕괴하지만 않으면 괜찮아' 정도의 마음가짐으로 임하는 것도 나쁘지 않을 듯하다.

完全崩壊
しなければいい

Design and manufacturing companies tend to have a culture of working late into the night, with frequent all-nighters. Another thing that's unique about this field: the many youngsters who join design firms filled with hopes and dreams, only to quit after realizing that they can't deal with the harsh reality of the industry. One way to deal with this problem is to improve working conditions in order to become a better company, but the constant search for staff is another thing that's particular about the design field. Perhaps a better attitude to have is "even if people quit. we're OK as long as we don't fall apart as an organization."

심플함을 추구하라

Refine simple things

'심플=간단, 저비용'이 아니다. 오히려 그와 반대로 숙고熟考가 필요하다. 심플함을 구현하기 위해서는 모든 복잡성을 정리하고, 서열을 정하고, 불필요한 부분을 없애 스스로의 존재를 지워가기 위한 극한의 노력이 필요하다. 방대한 검토 과정만이 디자인의 가치가 되고 그러한 과정이 반복될 때 브랜드가 태어난다. 엄청난 시간과 비용의 자기 투자 또한 필요하다.

シンプルを極めよう

"Simple" doesn't mean easy and low-cost — the opposite, rather. Simple things require you to mull over them. The act of refining simple things demands an incredible effort to sift through all the complexities that they entail, rank them, eliminate the extraneous — and even a sense of itself as an object. The sole value of design lies in the countless investigative and analytic processes that it involves, and a brand is what emerges from repeated iterations of these processes. That's why design requires an overwhelming self-investment in terms of both time and money.

**Work with
someone in mind**

사람을 먼저 생각하고
사람을 위해 일하라

사람을 생각하지 않은 작업은 디자인이라 할 수 없다. 좋은 디자인은 타인에게 도움이 되고 그 결과가 최종적으로 디자이너 자신을 위한 것이 된다. 자신을 위한 작업은 어디까지나 결과일 뿐 결코 목적이 되어서는 안 된다. 이러한 진리는 물론 디자인을 갓 배우기 시작한 사람들에게도 적용된다는 사실을 잊지 말자.

人 の

ためになろう

Work that doesn't have a particular audience in mind can't be called "design". Good design serves the needs of people, and ultimately becomes something you produce for the sake of yourself. This act of working for yourself is really a kind of end result — it can't be an objective in and of itself. This applies not only to your clients, but also to budding designers who spend a period of time working under their superiors or more senior figures.

반응하라

Nod

일본 사람들은 대화를 할 때 고개를 끄덕이는 습성이 있다. 습성이 다르다 해도 무슨 의미로 고개를 끄덕이고 있는지 정도는 전해질 것이다. 일일이 반응하는 태도가 호감을 줄 수도 있다. 별 의미 없이 끄덕인다 해도 그것이 불신감을 주는 경우는 드물 것이다. 그러니 반응하라.

うなずこう

Nodding — that most Japanese of habits. The other person is no idiot, you know. He can tell what you're thinking when you nod at him. On the other hand, nodding also tells him that you're reacting to everything he says and does, which ought to give him a good impression of you. There aren't too many people who would distrust someone who nods without good reason.

누구를
위한
디자인인가

Whose
design
is it?

나름대로 만족스럽고 훌륭한 디자인이라도 실제로 사용할 소비자가 감당하기 어려운 디자인이라면 의미가 없다. 누구를 위한 디자인인가? 그 답을 찾아낸다면 디자인의 50퍼센트는 이미 완성된 것이나 다름없다.

デザイン
は誰のモノかを
見つけよう

No matter how great a design you manage to come up with, it's not going to mean anything if the end users who will actually interact with the product are going to find it unwieldy. Who are we designing for? If you can answer that, half the battle is won.

デザイン

타인을 만족시켜라

DESIGN

**Satisfy others with
your design**

디자인은 타인을 만족시켰을 때 비로소 가치를 갖는다. 사실 자기가 만족하는 디자인을 만들어내는 일은 간단하다. 타인의 관점에서 아이디어를 평가하고 작업을 진행하라. 이러한 상황에서 이리저리 형태를 바꿔가면서 끈질기게 살아남은 디자인이 진짜 디자인이다. 그리고 디자인을 보여주는 일은 일종의 엔터테인먼트다. 간단한 미팅, 대규모의 프레젠테이션 할 것 없이 반드시 고객의 기대와 상상을 초월한 결과물을 제시하라.

C
B
A

デザイン
デザイン
DESIGN
で他者を満足させよう

Design work has value only when the designs satisfy other people. It's actually easy to create self-satisfactory designs. Review your idea from the other person's perspective and criticize it. Though they change in form, designs that tenaciously survive this are the genuine ones. In addition, a design presentation is a form of entertainment. Regardless if it's a small meeting or a large-scale presentation, you should always present outputs that exceed the clients' expectations and imagination.

인상적인
사진을
준비하라

Take good photos

디자이너에게 있어 사진만큼 유용한 마케팅 도구는 없다. 미디어는 멋진 사진으로 지면을 꾸미고 싶어 하고, 실물을 볼 수 없는 해외잡지의 필자들은 메일에 첨부된 사진을 보고 글을 쓰는 경우가 많다. 디자인 어워드에 응모할 때도 사진은 중요한 역할을 한다. 디자이너의 인물사진도 확실히 챙겨둘 것. 선전을 위한, 인상에 남을 사진 한 장을 꼭 준비해 두자.

良い写真を撮ろう

Photography is the best marketing tool that a designer can possibly have. Magazines love to have nice photos within their pages, and correspondents for international publications who don't have access to the real thing will write articles based on photos attached to your emails. Photos also play a key role when applying for design awards and submitting work to competitions. Make sure you have a proper portrait taken, too — it's your public image we're talking about, so you'd better have a picture that will make an impression.

방임하지 마라

Always keep one
eye on your staff

후배 디자이너가 하는 일을 주의 깊게 살피고, 혼자 놔두는 일도 없다. 잘못한 일에는 일일이 화를 낸다. 어떤 이는 감시라도 하느냐고 묻는다. 하지만 실제로 한 사람을 주의 깊게 볼 수 있는 시간은 하루 한 시간이 한계다. 나머지 시간은 서로의 생각을 공유하는 일조차 여의치 않다. 때문에 하루에 한 시간만이라도 후배나 직원과 진지하게 마주 대하려 노력한다. 함께 있는 시간마저 방임한다면 무엇을 공유할 수 있겠는가.

Don't let anything your staff do pass you by, but also make sure you don't leave them entirely to their own devices. Get mad at every single thing they do, to the point where they feel like they're under constant surveillance. Keeping a serious eye on one person for one hour in one day, however, should be as far as it goes. The rest of the time, you won't even be able to be conscious of each other's existence. Make sure that you have ay least one hour of serious face time. You won't get anywhere if you let even the amount of face time with your staff take its own course.

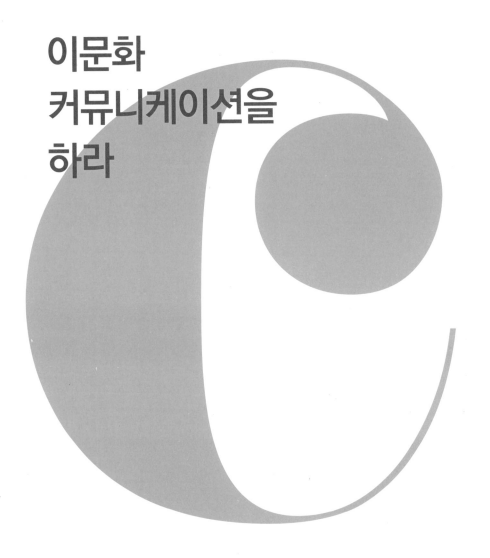

이문화
커뮤니케이션을
하라

Participate in cross-cultural
communication

의사소통에 힘써볼 생각이 있다면 의외로 해외에서 작업이 가능하다. 손짓 발짓, 때로는 필담으로 어떻게든 통하게 되어 있다. 클라이언트는 훌륭한 디자인이 필요한 것이지 디자이너의 언어 능력을 시험하려는 것이 아니다. 필요하다면 통역을 준비할 것이다. 그렇지만 역시 자신의 언어로 전달하는 것이 정확하고 만족스러울 것이다. 어쨌든 일에 대해 동기부여가 되기만 한다면 커뮤니케이션 문제는 해결 가능하다.

異文化コミュニケーションをしよう

If you have the energy go communicate, working overseas is unexpectedly easy. There are many ways to communicate, such as with gestures or writing. Clients just want splendid designs, and don't care about testing the designer's language skills. If necessary, they will bring an interpreter. However, communicating in your own words is more accurate and is more satisfying. When such motivation arises, communication problems are mostly solved.

Design

해외에서도 일해보라

Work overseas, too

Design

70억 명을 상대로 일해볼 수는 없을까. 다시 말해 전 세계를 상대로 일하는 거다. 디자인 분야는 무한하며, 문화나 철학의 숫자만큼 답이 존재한다. 디자인 자체가 말을 건네기 때문에 언어의 차이는 문제가 되지 않는다. 언어 때문에 생기는 커뮤니케이션 부족은 열정과 재능으로 보충하면 된다.

海外 でも 仕事
をしよう

If it's something that's within your reach, don't just make things that target the 130 million people in Korea, but the 7 billion people around the world as well. The field of design is limitless. There are as many answers and solutions to design issues as there are cultures and ways of thinking in this world. Design can speak eloquently for itself, so differences in language aren't really an issue. Communication that is lacking in linguistic terms can be made up for through passion and talent.

자신의 국적을
의식하지 마라

Do not have an
over-eagerness to
be Nation

"로마에 가면 로마법을 따르라"고 하지만 디자인 작업에서는 그러지 않는 편이 좋다. 클라이언트는 '한국인 디자이너'인 당신에게 의뢰한 것이기 때문이다. 가장 자신 있는 디자인을 상대방이 이해하기 쉬운 방식으로 설명하는 것으로 충분하다. 단, 자신의 나라를 의식하지 않아도 된다. 애써 의식하지 않아도 당신의 디자인에는 자국의 정서가 녹아 있고 그것에서 벗어날 수도 없을 테니까.

Although the expression goes "when in Rome, do as the Romans do", it is better to not follow this dictum in design work, since the client offered you the job because they considered you a "Korea designer". If you show them a design that you are good at, which has been slightly modified to make it easier for them to understand, they should be happy. Furthermore, don't be conscious of Korea. Your designs are unconsciously Korean-like, and cannot escape that fact.

'이중인격자'가 되라

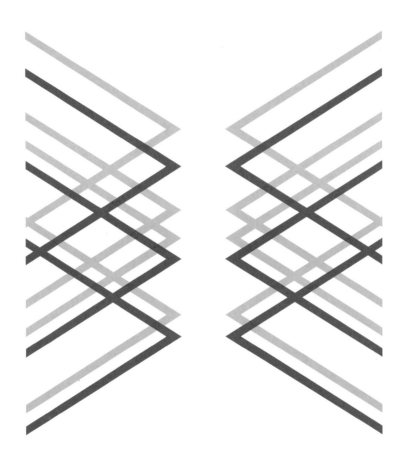

Have a double
personality

'오타쿠'인 나와 '오타쿠'가 아닌 내가 되라. 전문 분야에 빠져 살면서 동시에 다른 분야에 대한 관심도 함께 가져야 객관성을 유지할 수 있다. 어느 한쪽에 치우친다면 일이 아닌 취미로 끝나버릴 가능성이 높다.

二重人格
であれ

Cultivate both the nerdy and non-nedy aspects of your personality. Get an objective view on things by having access to references outside your field of expertise, even as you remain committed to your specialty. If you only have one or the other, you run a high risk of remaining a hobbyist, not a professional.

'글자 하나'가
주는
느낌까지
생각하라

글자ㄱㄹㅈㅎㄴ

Think hard about the
impact
that single world will
make

디자이너라면 초대장의 글자 하나가 주는 이미지까지 마음을 써야 한다. 일상적으로 사용하는 편지지나 봉투 같은 문구에서 웹사이트에 이르기까지 대외적으로 사용되는 모든 것이 회사의 얼굴이라는 사실을 잊어서는 안 된다.

「その1文字」が与える印象を考えよう

Designers ought to think hard about the impression that even a single word in particular font on your cover letter will make on the recipient. Every object bearing your name that goes out into the world — from the envelopes, letterheads and other stationery that you use on a daily basis to your website — is the public face of your company.

상대방의 시점을
시각적으로
떠올려보라

Visualize things
from the other person's
perspective

사물이나 공간이 나 이외의 다른 이들에게 어떻게 보이는지 검토하라. 실제로 그들의 시점에서 확인하는 일을 통해 많은 것을 새롭게 깨달을 수 있다.

相手の
視点を

ヴィジュアルで
イメージ
してみよう

How do other people look at objects and spaces? Lots of things become obvious when you actually put yourself in someone else's shoes and verify for yourself.

일에 지쳤다면
자, 휴식을

Take a break
if you're tired

쉬어야 할 때는 쉬어라. 휴식은 권리이자 활력소다. 책상 앞에 앉아 차를 마시며 인터넷을 하는 어정쩡한 휴식을 말하는 게 아니다. 밖으로 나가 축구를 하든 쇼핑을 하든 '치맥'을 하든 자유롭게. 마치 당신이 게으른 것처럼 보이더라도, 당신의 상사는 그것을 이해해야 한다.

仕事に疲れたら、どうぞ 休憩 を

It's important to take a break. Time away from work is a right, and it helps to take the edge off a bit. It's not a cop out to have some tea while surfing the Internet at your desk. You should even fell free to go out and play some soccer, do some shopping, or have a drink. Even if it feels like you're slacking off, your boss ought to be fine with that.

생산자와

소비자를

연결하라

Connect

creators

with users

물건은 최종적으로 필요한 사람에게 가게 된다. 하지만 필요한 사람으로부터 직접 주문을 받아 제작하는 물건만 있는 것이 아니다. 일정량 이상 만들어지는 제품은 중간업자를 거쳐 소비자에게 전달된다. 중간업자는 상사일 때도 점포일 때도 있는데, 디자이너는 그들이 팔기 쉬운 제품 또는 디자인을 염두에 두어야 한다. 제품의 장점을 그대로 드러내는 디자인이 존재한다.

つくり手とユーザーをつなごう

Products ultimately end up in the hands of the people who require them, but not all of them are made in responses to a direct order from the end users. Products that can be manufactured in considerable quantities generally pass through the hands of several middlemen before reaching the user. These middlemen can be trading firms or individual shops, but the products they handle need to sell easily, or have designs that appeal readily to customers. In general, these people are "designed" in a way that allows them to expound on the merits of a particular product.

**Analyze your own position
and capitalize on it**

독자적으로 도전하고 싶은 마음은 이해하지만 최고의 디자이너 밑에서 일하는 것도 독립한 것과 마찬가지라고 볼 수 있다. 나다운 플레이가 가능하다면 굳이 최고의 위치에 있을 필요는 없다. 축구선수 나카무라 스케中村俊輔처럼 최고의 디자이너를 움직이는 위치와 역할도 있다는 사실을 알자.

It's natural that you want to take on all these challenge by yourself, but the position just behind the striker is also an autonomous one. It's not such a bad thing to stay in the backseat. The frontline isn't the only place where you can make the best of your talents — just like the soccer player Shunsuke Nakamura. The task of supporting the front man is also an important one.

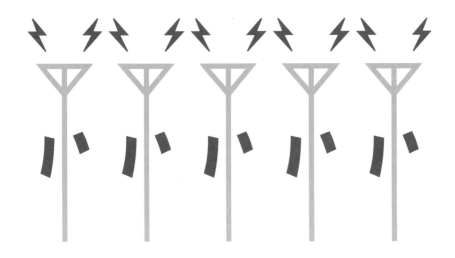

정보에 민감해져라

Perk your ears up to
information
that will make the most
of your abilities

시간을 들이면 좋은 디자인이 나올지 모른다. 하지만 역량은 시간이 충분하지 않을 때 발휘되는 것. 역량을 키우기 위해서는 일상생활 중에 접하는 정보들을 순간적으로 잡아내는 일이 중요하다. 출근길을 떠올려보라. 수많은 상점, 회사, 사람들이 있다. 곳곳에 실마리가 널려 있다. 매일 보는 뉴스는 어떠한가? 자신의 일처럼 생각하고 이해하고 있는가? 모든 것을 탐욕스러울 정도로 흡수하라.

力量を発揮するため

情報

に敏感であろう

Maybe you'll come up with something amazing if you just invest the time, but it's only when you're pressed for time that your skills are really put to the test. In order to cultivate these skills, it's also important to quickly pick up on any snippets of information that might cross your path over the course of your daily routine. All the shops and restaurants, offices, and people on the journey form your home to the train station, for instance, are rich sources of clues and hints ripe for the picking. Are you taking in the news for the day by seeing how it relates to you personally? Make sure you greedily absorb everything around you with a passion.

A

가까운
사람들에게
물어라

Ask
someone
nearby

나의 실체를 잘 알고 있는 가족은 가장 엄격한 평론가다. 그들에게 디자인에 대한 생각과 자세를 평가받도록 하라. 일반인의 객관적인 시점이나 생계를 함께하는 이들의 관점에서 나온 의견은 디자인이나 비즈니스 감각을 재고해볼 수 있는 좋은 계기가 된다. 그리고 시안試案이 어느 정도 확정되면 가족이나 연인 앞에서 설명하는 자신을 상상해보라. 당신의 의도가 충분히 전해졌는지. 유연한 사고로 아이디어를 재검토하는 방법으로 적극 추천한다.

躬な
人
に聞こう

Your family knows your true self and they are your bitterest critics. Ask for their opinions about your attitude towards design or way of thinking. Opinions with objective perspectives from the general public or from someone who you live with provide good opportunities to reconsider your designs or business sense. Also, when you are at a point where your design idea is roughly taking shape, imagine yourself explaining it to your family or lover. Can you explain it well? This is a recommended method for reviewing your idea with a relaxed state of mind.

큐피트가 되어라

Become a cupid

흥미로운 화학반응이 기대되는 사람들의 만남을 주선하라. 기회를 제공하는 것만으로 충분하다. 물론 자신에게 돌아올 득과 실은 따지지 말 것. 이 과정에서 '가교架橋 디자인'을 발견하게 될 것이다.

キュ✳ピッド
になれ

Try to connect people who might have interesting chemistry together. All you need to do is provide a place where they can meet. Of course, don't think about what you stand to gain or lose by this matchmaking process. Before you know it, you've managed to "design" yourself a position as a kind of mediator or middlemen.

언어적
　　표현으로
바꿔보라

**Put it in
words**

디자인할 대상을 언어적 표현으로 가정해서 접근해보라. 예를 들어 사진 촬영을 할 때 '어둠을 찍는다'는 설정에서 출발해보자. 어둠(검정)이라는 개념에서 농도, 깊이, 노출 등 다양한 접근 방법이 떠오를 것이다. 사진에서 언어로, 언어에서 다시 사진으로.

One possible working approach is to come up with a provisional term or phrase to describe it. For instance, trying to "capture darkness" during a photo shoot. This will inspire various approaches inspired by the gradations that exist within black, a sensation of depth, or the time involved in long exposures. Take a photo, express it in words, and then take the photo again.

가장
아름답게
보이는
상태를
찾아라

Look out
 for things
at their
 most beautiful

양변기는 뚜껑이 닫힌 상태가 가장 아름답다. 모든 물건은 저마다 가장 아름답게 보이는 상태가 있다. 각각의 장면에서 그것을 탐구하고 실천하는 일을 잊어서는 안 된다. 아름다운 것을 세상에 내보내는 역할을 맡고 있는 사람이라면 볼일을 마친 후 변기 뚜껑을 닫아야 직성이 풀릴 만큼 철저하게.

最も美しく見える状態を探そう

A western-style toilet looks most beautiful when the cover is closed. All objects in this world have an ideal state that makes them look their best. As a designer, never forget that it's your job to keep searching for and implementing these situations wherever you can find them. Those whose role it is to bring things of beauty into this world should always remember to close the lid on the toilet after you finish your business.

실감을 믿어라

Trust your gut feeling

업계의 관습에 연연하지 말고 경험을 통해 얻은 실감實感을 근거로 결정하라. 비상식적으로 보이는 결정이라도 경험을 통해서만 실제적인 위험 요소와 기대치를 산출할 수 있다. 가장 신뢰할 수 있는 것은 당신이 실제로 느낀, 바로 그것이다.

Decisions should be made by ignoring industry conventions and relying on gut feelings that are acquired through your own experiences. Even if it lacks common sense, you can only calculate realistic hopes and risks through your gut feelings. The most reliable thing is your gut feeling.

인사도
디자인이다

Greetings are
design, too

사람과 만날 때는 인사로 시작해서 인사로 끝난다. 우리 회사에는 손님이 오면 전 직원이 하던 일을 멈추고 인사를 해야 하는 규칙이 있다. 인사를 하지 않으면 방문하는 사람을 존중하지 않는 것처럼 비칠 뿐 아니라, 그런 마음가짐으로는 좋은 디자인을 만들어낼 수 없다. 인사는 'your time, your pace, service for you'라는 디자인 마인드의 표현이다.

挨拶も
デザイン

Meeting someone begins and ends with a formality or greeting. One of the rules at our firm stipulates that all staff leave their work, no matter what they may be in the middle of doing, and greet visitors who've arrived at the office. Not greeting visitors shows a lack of respect for these people, which will never lead to good design. Greetings tell other people that you provide a service at their own time, pace, and convenience.

성공적인 하루의 시작은
아침식사

**The key to a successful
day is breakfast**

생활의 기본은 컨디션 관리다. 프리랜서는 생활이 불규칙해지기 쉽다. 밤늦은 작업이나 철야가 효율적인가 다시 한번 생각해보라. 일찍 일어나 꼬박꼬박 아침을 챙겨 먹으면 하루를 긍정적으로 시작할 수 있다. 아침식사로 생활과 일에 리듬을 만들어주자.

一日の計は朝食にあり

Keeping in good shape is the foundation of life. Freelancers tend to have irregular schedules. Stop and think about the efficiency of working all night or late at night. By waking up early and eating breakfast, you can start the day in a positive manner. Regulate your life and work rhythms by having breakfast.

고객 중심

Be customer-driven

'고객 중심'이란 '자기중심'을 벗어나 다른 곳에서 출발하라는 디자인의 기본 자세를 가리키는 말이다. 아무리 훌륭한 디자인이라도 사람들이 받아들이지 못하는 일방통행적 작업이라면 디자인이라 할 수 없다. 상대방의 존재를 느끼면서 창조해야 하며, 생활 속에서 살아 있어야 디자인이 된다.

顧客

本位であれ

Obviously, "customer-driven" doesn't mean that you should be ingratiating. On the other hand, avoid striking out on your won at all costs when it comes to design. No matter how wonderful your design is, if it's just a one-way thing and not accepted by other people, you can't call it "design" in the strict sense. Make sure to create things with your client or end user in mind. Design comes about by living in the real world.

젊은
디자이너
중심으로
운영해보라

WAKATE

Create teams of mostly
young people

경험이 많은 디자이너는 지식도 풍부하고 실수할 확률도 적어 확실한 결과를 남길 가능성이 높다. 하지만 과거의 성공에 얽매이기 쉽고 새로운 일에 도전하려는 의욕이 적을 수 있다. 그렇다면 한 프로젝트 정도는 모두 젊은 디자이너로 꾸려보는 것은 어떨까. 특히 핵심 업무가 있다면 그것을 맡겨보라. 핵심 업무가 오래 지속될 수 있을지 모른다. 가장 무서운 적은 매너리즘이기 때문이다.

Thanks to their previous experience, managers and veteran staff members may be able to deliver solid results with few mistakes by putting their extensive knowledge to use. But they tend to stick to their previous successes, and may not have the inclination to take on a new challenge. So maybe it's a good idea to deal with certain projects using a team made up entirely of younger staff. This is particularly true if the mainstay of your business is in good shape — you should just try leaving it to the youngsters. This way, your core business might even prosper longer. The worst fate of all is to get stuck in a predictable routine.

어머니가 되어보라

Become a mother figure

여성이라면 디자인 외길이 아닌 이상, 한번쯤은 어머니가 되어보았으면 한다. 다른 세계를 가져 균형을 이룰 수 있고, 다른 경로를 통해 도움이 되는 발견을 할 수도 있다. 디자인이란 생활과 밀접한 분야이기 때문이다. 그리고 어머니의 다정함과 강인함은 위대하다. 그것을 체득한다면 틀림없이 어떠한 상황도 헤쳐나갈 수 있을 것이다.

Instead of devoting yourself wholeheartedly to your work, what women really want is for you to try and see what it's like being a mother. Becoming a mother gives you a fine balance between various elements because you have access to different worlds, and design bears an intimate relationship to life itself, so being attuned to different "channels" and wavelengths goes a long way. The tenderness and strength of a mother are noble qualities to have, as well. If you can tackle your work with these traits on your side, you shouldn't have a problem dealing with even the toughest of situations.

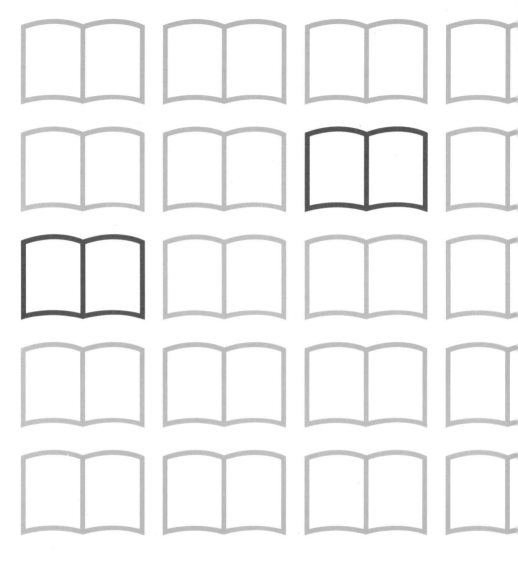

스토리를 PR하라

Sell those stories

디자이너는 스토리를 PR하는 일에 지혜와 창의력을 쏟아 부어야 한다. 또한 그러한 노력은 일정 기간 계속할 필요가 있다. 많은 언론매체들을 대하다 보면 '디자인이 어떻게 보여지는가'가 중요하다는 사실을 깨닫는다. 그 하나 하나가 모여 브랜드가 되고, 브랜드 이미지가 된다. 자신의 디자인을 통해 타인의 평가를 끊임없이 관찰하는 일. 주요 인물로부터 얻은 조언이나 평가를 디자인에 확실히 반영하는 일. 그러기 위해서는 무엇보다 오랜 관계를 유지하는 일이 중요하다.

Designers ought to devote their knowledge and creativity to launching PR campaigns that will drum up public interest in stories, in a continuous way for a fixed period of time. Dealing with lots of press and media people will make you realize the importance of how design is seen and regarded. All these things are expressed in the form of a brand. Keep an eye on public opinion through your own designs. Advice, feedback, and appraisals from the key players in the industry will definitely been reflected in your design work, so a long and lasting relationship with them is essential.

식사를 디자인하라

Design the meals you
have together

식사는 디자인이다. 클라이언트와 식사를 할 때 일 이야기는 하지 말라. 서로가 어떤 사람인지를 확인하는 자리이니 비즈니스적으로 접근하지 않아야 한다. 식사를 하며 개인적인 소통이 가능했다면 식사 후 업무 미팅도 대개 성공적으로 진행된다. 클라이언트는 신뢰를 쌓을 준비 단계로 디자이너와 식사를 한다는 사실을 기억하라.

Food is design. Make sure you don't talk about work whenever you have dinner with your clients. These occasions are when you're trying your best to find out more about each other as individuals, so leave your business persona at the door. If you can have a lively conversation during the meal, the meeting that follows will typically go well. Your clients are having a meal with you as a preliminary step to entrusting their concern to you.

침묵은 금물

Don't keep silent

결론을 내기 위한 것인지 아니면 의논을 하기 위한 것인지 회의의 목적을 확실히 하라. 결론을 위한 것이라면 결론이 날 때까지 끝내지 않기. 의논을 위한 것이라면 침묵하지 않기. '지금 생각 중입니다'라며 아무 말도 하지 않는 사람은 대부분 아무 생각이 없거나 발언할 용기가 없는 경우다. 회의를 기회로 순발력을 길러라.

沈 默

しない

Hold meeting with clear objectives — are we here to reach some kind of conclusion, or talk things over? If it's the former, don't end the meeting until you reach the conclusion. If the latter, make sure nobody stays silent on the matter. Some people are going to refuse to contribute and say "I'm still thinking about it", but most of the time they haven't thought about it at all. Use these sessions as opportunities to train your staff to perform when put in a tight spot.

불특정
다수를 향한
발언은
금물!

Address a specific
audience

특정 대상을 타깃으로 한 서비스를 하고 있다면 불특정 다수를 향한 발언을 삼가는 것이 좋다. 이런 태도는 결과적으로 필터가 되어 좋은 일거리를 가져다 줄 것이다.

A niche service that is not a mass product shouldn't speak to a general audience. The nature of your work ultimately serves as a filter, and gets you the choicest jobs.

독창성을 검증하라

Verify originality

정보나 유행은 무의식 중에 기억된다. 상당히 좋은 아이디어가 떠올랐다면 그것이 독창적인가를 반드시 다양한 각도에서 검증해 보라. 이미 다른 디자이너가 생각해낸 진부한 아이디어일 가능성이 높기 때문이다. 독창성을 가진 디자인만이 오래 살아남을 수 있다.

オリジナリティを検証しよう

Information and trends are naturally absorbed by your mind. Even when you come up with a wonderful idea, it is highly likely that the idea has already been used by another designer and has become obsolete. It's important to verify from all sides to see if the design has originality. Only designs with originality can endure for the long term.

아름다운 일을 하라

Make beautiful work

완성도가 높은 작품은 '아름답다'. 디자인이나 예술의 세계뿐 아니라
어떤 분야라도 완성도가 높은 일은 아름답다.

仕事は
美しく
あれ

Highly polished work is beautiful. This applies to all sorts of work, not
just the world of art and design.

함께 일하는 사람과
좋은 관계를 유지하라

**Become friendly with
those you work with**

함께 일하는 사람과 좋은 관계를 유지하면 반드시 좋은 결과를 얻을 수 있다. 반대로 서로 이해가 부족한 상태에서 일을 계속하면 문제가 발생하기 쉽다. 좋은 관계를 맺는 데는 시간이 걸리지만 신뢰를 잃는 것은 한순간이다. 디자인은 충분한 시간을 들여 상대방을 이해하는 일에서 출발해야 한다.

仕事をする人とは仲良くしよう

If you can become friendly with those you work with, you'll definitely be able to produce good work. Conversely, you're going to run into problems if you keep working without understanding these people at a personal level. While it takes time to get friendly with someone, you can lose someone's trust in a single instant. Design entails investing that extra bit of time to create interpersonal relationships from which your work will emerge.

약속 시간
10분 전

Arrive
10 minutes
ahead of
time

미팅이나 프레젠테이션의 분위기를 선점하면 비장의 카드가 될만한 아이디어나 모르고 지나쳤던 문제를 발견하는 등 뜻밖의 수확을 얻을 가능성이 높다. 약속 시간에 늦어 사과하는 말로 시작하는 상황만은 절대 피해야 한다.

約束の時間の

10分前

に到着しよう

Never misjudge the appropriate scale of the organization required to maintain the quality of your work. The moment the number of staff exceeds a certain limit, the standard of their work is going to nosedive. In order to maintain the quality of work expected, you need to find an ideal size and scale for your organization that corresponds with the content of the work and the abilities of your managers.

조밀함의
균형을 유지하라

Strike a balance between the coarse and fine

요즘 소비자는 필요한 물건만 산다. 종이책 출판 분야는 상황이 더욱 심각하다. 이렇다 보니 내용은 물론 디자인에 거는 기대도 커졌다. 그래서 지면을 의도적으로 조밀粗密하게 디자인하는 경우가 많아졌다. 조粗는 느슨하게 읽기 쉽게 하여 시선을 끌어 좋은 내용임을 강조하고 싶을 때. 밀密은 빽빽하게 정보량을 늘려 유익함을 강조하고 싶을 때. 물론 꼭 팔린다고 보장할 수는 없지만 말이다.

粗密のバランスをもたせよう

These days, consumers only buy what they absolutely need. This is even truer when it comes to books, which are moving away from paper at an alarming rate. Content now becomes a non-negotiable given, while the design of these books needs to appear useful and functional. When designing for paper, therefore, make sure you intentionally include a blend of coarse and fine textures. The coarse parts are more legible and make it easier for the eye to latch onto the text, emphasizing the quality of the content. The fine print, so to speak, conveys the volume of the information presented, and a sense of being functional and helpful. Of course, this approach doesn't necessarily mean that the title will sell...

대안을 생각하라

Find some other way

쑥스럽지만 나는 스케치를 하는 데 재주가 없다. 무언가를 그린다고 해도 실물과 달라 보이기 때문에 애초에 시도하지 않는다. 물론 스케치를 연습해 실력을 키우는 것도 하나의 방법이겠지만, 나는 다른 방법을 선택했다. 바로 정확한 도면을 그린 후, 최종 완성형을 상상하는 연습을 한다. 시간도 더 오래 걸리고 실수도 많지만 지금은 익숙해져 유용하다.

代替法
を考えよう

It's kind of embarrassing, but I can't draw to save my life and so I never make any sketches — or I do, but they always end up looking totally different from the real thing. Practicing how to sketch is one possible way of doing things, but you decided on a different method. You made an accurate diagram, and trained yourself to be able to envision the final product. It ate up a lot of time and you made lots of mistakes, but now you've acquired this skill that you can deploy in your work.

서로 다른
'8시간'

Pay
attention to
different
forms of
"time"

당연한 이야기겠지만, 다른 나라와는 시간차가 존재한다. 하지만 시간 뿐 아니라, 건물이 완성되기까지의 기나긴 시간, 마감을 중심으로 움직이는 편집자의 시간, 24시간 영업 중인 경영자의 시간 등 서로 다른 시간 개념까지 염두에 두자. 다양한 시간의 흐름이 존재한다는 사실을 인지하라. 서로 다른 시간 체계 속에서 진행되고 있는 일과 상대방에 대한 배려를 잊지 않는다면 원만한 관계를 유지할 수 있고 불필요한 문제도 피해갈 수 있다.

異なる
「8時間」への
思いやりをもとう

There's a time differences between Korea and other countries, of course. But what about value systems associated with different conceptions of time? The length of time it takes for a single building to be completed, for instance. The time of an editor with his mind always on his deadlines, or that of a boss who is always "on" twenty-four hours a day. When doing business, it helps to bear in mind that time flows in all sorts of ways, many of which obey a different rhythm to your own. If you respect the different paces at which each of your clients and projects operate — all of whom have their own conception of time — you'll be able to keep things going smoothly and avoid any unnecessary problems.

감정을
드러내
본심을
전하라

**Let
your
emotions
show**

웃는 얼굴도 중요하지만 정확하게 의사를 전달하지 않으면 상대를 이해시킬 수 없을 때도 있다. 사과할 때나 고마운 마음을 전할 때는 메일이 아닌 직접 얼굴을 보고 이야기하라. 멜로영화처럼 웃고, 울고, 화도 내고…. 감정을 드러내라. 언쟁하라. 분위기 파악을 잘하는 사람은 그저 좋은 사람일 뿐이다. 서로 부딪히고 본심을 드러내고 반성하라. 그래야 상대방의 기분을 진심으로 이해할 수 있다.

感情をぶつけて 本音 を伝えよう

It's important to smile, but you won't be able to make yourself understood if you can't speak freely. Don't apologize or thank someone in an email — express your feelings directly, in person. Shed tears, smile, get mad, just like in a romantic movie. Let those emotions show. Quarrel and argue. People who listen and empathize are nice, too — but they're just "nice". You need to get to grips with other people, hold nothing back, and then reflect on it. That way, you'll really understand how the other person feels.

70퍼센트까지
힘주기

Stop at
70%
for the
cool factor

디자이너라면 늘 개성 있는 디자인을 추구하고 싶다. 하지만 대부분의 소비자들은 앞서가는 디자인을 이해하지 못한다. 주문 제작한 맞춤 디자인이라면 문제가 안 되지만 대량 소비될 디자인이라면 다양한 고객층을 염두에 두어야 한다. 때문에 70퍼센트 정도 힘주는 게 적당하다. 즉, 70퍼센트까지만 엣지Edge 있게.

格好良さは 70%
70%にとどめよう

Designers tend to always be on the lookout for cool stuff. For end users, though, many of the more innovative aspects of design can be tough to get a hold on. Custom-made products can be said to be well designed as long as the client is satisfied, but products made for a mass market need to appeal to all sorts of people — both connoisseurs with refined tastes and sensibilities, and people who are completely insensitive to design. In order to turn an idea into a viable product, you need to make sure that it's "only" 70% cool. This often involves softening the "edginess" of the product, so to speak.

자신을
아름답게
빛나게
하라

**Make
yourself
look
good**

청결한 아름다움은 매력적이다. 나이를 먹더라도 자신을 가꾸는 일에
소홀해지지 마라. 아름답게 보여 손해 보는 일은 없다.

Everyone likes attractive people. Don't skimp on that beauty regimen
— make an effort to look good no matter how old you are. It never hurts
to look attractive.

일은
사회와 나를
연결하는
고리

{

**Work is something
that brings you closer
to society**

일이 없다고 생각하면 불안해지는 이유 중 하나가 바로 돈이다. 다만 돈이 생긴다고 해서 무슨 일이든 좋은 것만은 아니다. 먼저 사회와 어떤 관계를 맺고 싶은지 생각해 보자. 사회와 맺고자 하는 관계가 결과적으로 일이 된다면 최상일 것이다. 일이란 타인에게 바치는 시간이다. 그 시간을 어떻게 보내느냐에 따라 자신의 삶에 생기가 넘칠 수도, 그렇지 않을 수도 있기 때문이다.

仕事は { 社会 と 私 を

つなぐものと考えよう

Money is one of the main reasons why people become anxious about having no work to do. But it doesn't mean that anything goes as long as you have the money. Ultimately, the goal is to do work that addresses the question of how you want to be involved in society, and the specific things that you can accomplish. Work is about dedicating your time to other people. The strengths and weaknesses associated with that time will be returned to you in kind — a sort of karma or payback.

조금 멀리 생각하라

Think about
overreaching a little bit

사회생활을 막 시작했을 때는 좋은 아이디어가 있어도 인맥이나 돈이 없어 실현시키기가 쉽지 않다. 지금 하고 싶다고 생각하는 일은 실제로 3년 후쯤 가능할지 모른다. 먼저 지금 자신이 처해 있는 상황을 냉정하게 바라보라. 그리고 조금씩 발돋움해 도전하라. 이러한 노력이 쌓여 다음 과정의 발판이 된다.

Even if people have a wonderful idea right after beginning their career, they usually lack personal connections and money to realize the idea. The idea you want to work on now might be realized after three years. So, calmly consider the situation you are in, and then challenge yourself with things that are a little bit out-of-reach. The layers of such challenges lead you to the next step.

이름을 붙여라

name

name

name

name

name

name

Decide on a name first

프로젝트 팀을 만들었다면 먼저 팀 이름을 만들라. 팀 이름도 결정하지 못하는 사람들에게 멋진 미래는 없다. 팀 이름을 만들면 일체감이 생기고 책임감을 느끼게 되며 무엇보다도 팀 내 분위기가 극적으로 변할 것이다.

name **まずは名前を付けよう！**

Once you get your project team up and running, your first priority should be to pick a name. A team that can't even decide what to call themselves doesn't have a very bright future ahead of them. Choosing a team name will bring members together and make them take responsibility for the task, dramatically lifting the spirits of your team members.

불의의 일격을 가하라

Launch a sneak attack

약속 장소에서 회의 장소로 이동하는 짧은 시간, 회의 장소에서 차茶
가 나오기를 기다리는 동안 조금은 껄끄러운 세상 돌아가는 이야기를
해보라. 또는 묻기에 약간 멋쩍은 질문을 해보라. '꾸밈'없는 '본바탕'
이 튀어나올 때가 있다.

不意打ち
をかけよう

You have just a short window of time before you proceed from your
meeting point to the place where your meeting is going to be held — a
short interval after you arrive at the venue and sit down, but before the
tea is served. I tend to make small talk that might be slightly awkward,
or offer a listening ear to someone who might want to way the same.
The answers aren't going to come rolling off the tongue, but the will
get the message across.

제품명을 눈에 띄게 하라

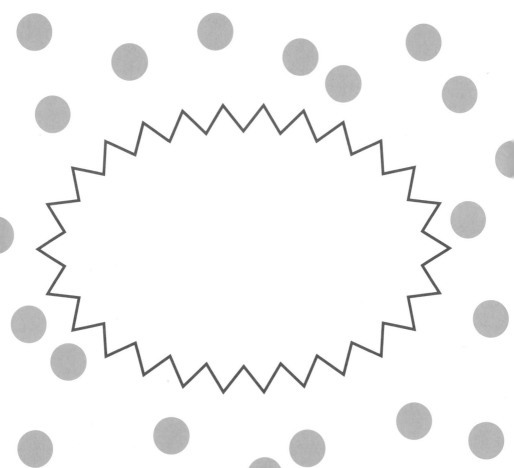

Find a name that stands out

패키지는 제품의 얼굴이다. 제품을 눈에 띄게 하기 위해 무엇을 강조
해야 할지, 다른 상품과 차별화하기 위해 어떻게 해야 할지가 중요하
다. 디자이너는 멋진 그래픽 요소와 영문 폰트로 시선을 끌려고 하기
쉬운데, 여기는 한국이라는 것을 기억하자. 우리의 글자로 확실히 PR
이 가능한, 멋진 디자인이 필요하다.

The packaging is the face of your product. Find out what about it
needs to stand out, so that consumers can recognize it instantly, or
distinguish it from other products. Designers tend to resort to nifty
graphic elements or cool-looking European fonts to make their work
stand out, but this is Korea. You need a solid PR campaign in Korean in
addition to a cool design.

제품으로 인식하라

Consider it as a product

'내가 입고 싶은 옷을 만들고 싶어!' 패션디자이너를 꿈꾸는 젊은이들의 이야기를 자주 접한다. 물론 사람에 따라 차이가 있지만 이런 사람들 중에는 디자인의 핵심이 되는 경험도 쌓지 않은 채 처음 동기 그대로, 자기만족으로 끝나버리는 이들도 많다. 먼저 옷을 '제품'으로 인식하라. 옷은 설계도(패턴)와 소재(옷감)로 완성된다. 이러한 기초를 배운 다음부터 '자신이 만들고 싶은 옷'을 고민해야 한다.

An often heard reason for young people to become fashion designers is, "I want to design clothes that I want to wear". Although it depends on each person, many of them create with such early intentions but lack experiences that become the center of the design, and as a result they only please themselves. To start with, just consider clothes as "products". Clothes are made with patterns and materials. It's important to think about "clothes that you want to make" only after learning the basics.

전망 좋은 곳에서 바라보라

Get your bearings where the view is better

일을 하다 보면 무수히 망설이게 된다. 여러 번 길을 돌기도 하고, 방향을 잃을 뻔하기도 한다. 한 번쯤은 큰길로 나가보라. 확 트인 길에서 새로운 랜드마크를 찾아 그곳을 향해 발걸음을 옮겨보라.

 通しのよいところで見てみよう

You're going to lose your way many times. If you start to lose your way after making too many turns, get out of there and make your way out to the main road. Find some landmarks where you have a better view of things, and make your way towards that direction.

가치를 부여하라

Assign value to what you cannot see

보이지 않는 것에 부여된 형태를, 다시 한번 형태가 되게 해보라. 사진에 피사체를 담는 일이 바로 이러한 작업이다. 아직 보이지 않는, 형태를 이루지 않은 사물이 가진 각각의 조건을 읽어내고 정착시키는 일. 이것이 전부는 아니지만 하나의 관점을 부여하는 일 또한 디자인이다.

見えないものに
価値を与えよう

Take invisible things that have already been given a form, and imbue them with yet another form. This is analogous to the act of capturing a subject through photography. Learn how to decode the various parameters pertaining to objects and things that aren't yet visible, or which haven't taken on a palpable form, and nail them down. This isn't necessarily crucial, but one of your jobs is to make obvious a particular perspective and viewpoint.

여행을 하라

Travel around

인터넷으로 간단하게 정보를 얻을 수 있는 시대다. 시간을 들여 여행을 떠나라. 여행을 하면 경험이나 특정 정보는 간단하게 얻을 수 없다는 사실을 재확인할 수 있을 것이다.

旅
をしよう

Precisely because it is an age when information can easily be obtained through the Internet, spend time for traveling. By traveling, you can reaffirm experiences and certain kinds of information that can't be easily obtained.

찬사를 보내듯이 일하라

Create work as
if you were
paying someone a
compliment

피사체는 이미 눈앞에 있다. 존재하는 것에서 답을 찾는 일이 건축 사진 촬영이라는 작업이다. 타인의 작업이 무사히 끝났을 때 아낌없이 찬사를 보내듯 자신의 작업에 대해서도 긍정적인 자세를 가져야 한다.

賛辞を述べるような仕事をしよう

The subject's already in front of you. Eliciting an answer from within it is the job of an architectural photographer. The act of photographing that subject ought to be affirmative in a way that allows you to shower unreserved praise on a piece of work that has been completed without a hitch.

오늘 이룬
최상의
결과가

내일의
출발점

Today's best shot is
tomorrow's
minimum requirement

오늘 잘했다면 내일은 더 잘해야 한다. 한 번 성공한 일은 두 번째도 성공해야 한다. 그렇게 배웠다. 무엇보다 중요한 것은 오늘 내가 어디까지 해냈는가를 파악하고 그것을 복습하는 일! 이런 과정을 통해 내일이 열린다.

Today's high

今日の最高は

明日の最低ラインにしよう

It's not always the case that tomorrow is going to turn out better than today. But there are going to be superiors who believe that you show do a better job the next morning for things than you can do today — and have become particularly attached to their little slogan. Naturally, you want things to turn out better than they stand today. In order for that to happen, you need a clear idea of how well you did today.

 설문을 만들어
답해보라

Rank key challenges
from 1 to 5

고객의 요구사항을 1번에서 5번까지 설문으로 만들어 보라. 1번과 2번은 간단하게, 3번과 4번은 앞 질문을 응용해 만들라. 5번은 총체적인 내용으로 만들라. 그리고 순서대로 신중하게 답을 해보자. 1번이 풀렸다면 2번도 문제없을 것이다. 앞의 해답을 참고하며 3번과 4번으로 넘어가자. 쉽지는 않겠지만 여기까지 풀었다면 5번을 해결하고 결론을 내려보자. 고객의 요구를 경청하고 이해하여 순서를 정하는 일은 중요한 과정이다.

問1 から 問5
までの設問を据えよう

Whittle your client's demands down to a single issue that can be divided into 5 points. Address the simple things with the first two points, and the practical issues involved in points 3 and 4. Point 5 is the conclusion. Take care to solve each of these questions in turn — if you manage to solve number 1, the solution to number 2 will come to you naturally. You can then use the answers to these first two issues to tackle 3 and 4. Even if they're a bit trickier, solving 3 and 4 will allow you to address number 5 without a hitch, and lead you to your conclusion. Deciding how to tackle these issues in the right order after listening to your client's requirements is an important process.

미팅은
내 사무실에서

\ Hello ! /

Have meetings at your
own office

사무실은 디자인에 대한 생각을 나타내는 메시지다. 미팅은 자신의 사무실에서 하는 것이 좋다. 말로 이것저것 설명하기보다는 직접 보여줌으로써 전해지는 것들이 압도적으로 많다. 그리고 사무실 선택에는 균형 감각이 드러난다. 내가 도시 중심에 사무실을 두고 있는 이유는 두루 고객을 맞이하기 위해서다. 그리고 지방이나 해외로 이동하기 쉬운 출발 지점이 되어야 한다는 사실도 중요하다.

打ち合わせは 自分の オフィスに 招こう

\ Hello ! /

Your office sends a message to other people about your attitude to design, so invite clients over for meetings. Rather than explaining everything orally, your message gets across much better by having your clients see for themselves. Your sense of balance and judgment shows in where you decide to locate your office. I chose to base my firm in Chiyoda Ward because it's in the center of Seoul, so that I can work with clients in every direction without being biased. Being here also gives me a good starting position that offers easy access to locations outside Seoul or overseas.

일을 한정 짓지 마라

Don't limit your scope

이름을 붙여 일을 한정해버리는 경우가 있다. 예를 들어 카메라맨, 사진가, 사진기사, 포토그래퍼… 다양한 명칭이 있지만 다른 명칭을 한 번 생각해보라. 평소에 하고 있는 작은 일을 적극적으로 해봄으로써 파생되는 활동도 있다. 광범위한 활동의 결과가 개성이 되고, 결과적으로 명칭이 되면 좋을 것이다. 바꿔 생각하면 명칭을 새롭게 설정함으로써 새롭게 전개되는 일도 있지 않을까.

仕 事 を
隈 定
し な い

Using names and labels like "cameraman" or "photographer" can sometimes place unnecessary limitations on your work. There are lots of titles out there, but make an effort to think of something different. There are also activities and projects that emerge because you've taken a more proactive approach to dealing with little everyday things. The results of a wide-ranging practice become trademarks, and hopefully bywords or calling cards associated with that person. Your career and future projects might flourish even more just by reconsidering the terms you use to refer to yourself.

계획을 세워라 ②

Make proper plans

상사의 지시, 정해진 기한 등 해야 하는 모든 일을 종이에 적어보라. 기억만으로는 잊고 있는 일도 있을 테니 재확인이 필요하다. 메모를 통해 우선순위를 정하고, 필요한 시간을 계산해 목표를 세울 수 있다. 모든 일을 하루에 끝낸다면 자신감이 생기고 상사에게도 인정받을 테니 일석이조.

①段 ②取り ③を ④大事に ⑤しよう

Write out everything your boss has told you to do, as well as all tasks and appointments with confirmed dates and deadlines. You're going to forget if you just rely on your memory, so make sure to always double check. This way, you'll be able to order things according to priority, make sure to accomplish a certain task within the allocated time, and frame other concrete objectives. Not only will your self-confidence get a boost when you get everything done within a single day, you'll also make a great impression on your boss.

자연스럽게
보여줘라

Keep
your
work
natural
and
innocuous

개인적이고 자의적인 결과물은 피하라. 기시감*이 쌓여 이질감을 주지 않는 작품이 완성된다. 첫눈에 자연스럽게 보여지기란 쉽지 않다. 상당한 노력이 필요하다.

*기시감既視感 : 경험한 일이 없는 상황이나 장면이 이미 경험한 것처럼 친숙하게 느껴지는 일.

自然に
障りなく
見せよう

Avoid producing end results that are too individualistic or arbitrary. Unassuming work is the result of a prolonged, accumulated sense of déjà vu. Things that seem to have come about naturally, or which appear innocuous, often involve enormous amounts of time and labor.

현장을 둘러보라

Do your site recce

새로운 작업 현장은 자고로 빨리 적응하고 싶은 것이 인지상정이다. 예를 들어 사진촬영 현장에서는 공간을 조율할 수 있도록 운동 전에 몸 풀기 체조를 하듯 현장 안을 걸어 다녀보자. 흐름이 끊기지 않게 촬영하는 데 도움이 된다. 공간과 앵글이 익숙해질 즈음에는 피로가 쌓여 대충하고 끝내고 싶은 마음이 든다. 그러면 그런 대로 좋은 작품이 나올 때도 있다.

現場では
歩き
ろう
◉

It's a good idea to get properly acquainted with the site you'll be working at as soon as possible. Walk around as if you were warming up before exercising in order to get in tune with the space. You'll synchronize even better with the location by shooting continuously, so that your "flow" won't be interrupted. When you start to tire of the familiar angles and objects within that space, a certain sloppiness will begin to show, and you can sometimes just shoot it that way.

선배들이 쌓은 가치를 존중하라

Respect the values put
in place
by those who came
before you

선배 디자이너들이 특정 장르를 구축해 온 덕분에 오늘 나의 일이 있다는 사실을 기억하라. 예를 들어 사진에서는 사진의 가치, 미적 기준, 앵글, 작법 등 과거의 선배들이 쌓은 가치를 침해하지 않도록 주의하라.

先人の
築いた価値を
尊重しよう

You're able to pursue the work you do today thanks to the specific genres created by your predecessors. In the case of photography, this includes the values associated with the medium, aesthetic criteria, camera angles, and established protocols. Make sure you don't devalue the foundations that these people have built.

조건을 이점으로 삼아라

Turn your
circumstances to your
advantage

일의 조건은 전부 외부에서 오는, 타인에 의해 정해진 제약이다. 디자이너는 이러한 제약 속에서 결과를 내야 할 때가 많다. 기한 내에 성과를 거두기 위해서는 타이밍과 분위기, 기상 조건 등도 염두해야 한다. '수동적 공로'라고 할 수 있을까. 최상의 결과를 내기 위해서는 주어진 조건을 이점으로 삼는 수밖에.

条件 を 味方 に 付けよう

The conditions that govern your work all come from the outside. Typically, you're working to craft something out of the restrictions and limitations that arise from what other people have already put in place. In order to produce results within a limited time frame, you have no choice but to make decisions based on timing, the time period given to you, and the weather conditions involved — basically, working from a defensive or passive position. In order to have maximum impact, you need to turn the given circumstances to your advantage.

순수함을
잊지 마라

Keep your heart and mind pure

나이가 들고 경험을 쌓았다면 이때부터 의식적으로 순수한 눈과 열린 마음으로 사물을 바라보라. 어떤 일에도 '익숙해지지' 않도록 자신을 경계하라. 잘못을 지적해주는 사람이나 화를 내주는 사람에게 감사하라. '아직 지금부터'라는 자세가 미래의 자신과 일을 결정한다.

Make a conscious decision to look at things with a clear mind unclouded by preconceptions after you've chalked up years of experience, and try to tackle things with an open mind. Don't let yourself "get used" to anything. Be grateful to nitpickers and those who get mad at you. Staying humble and modest about your own abilities will have a direct impact on how you develop in the future, and the work that you'll be capable of.

조직의
적정 규모를
고려하라

Keep to an ideal size

작업의 질을 유지하기 위한 조직의 적정 규모를 따져보라. 인원이 일정 수를 넘어서는 순간 작업의 질은 크게 떨어진다. 기대치를 유지하기 위해서는 일의 내용이나 관리자의 능력에 맞는 적정한 조직의 규모를 찾아내야만 한다.

組織の
ほどよい

規模を
考えよう

Never misjudge the appropriate scale of the organization required to maintain the quality of your work. The moment the number of staff exceeds a certain limit, the standard of their work is going to nosedive. In order to maintain the quality of work expected, you need to find an ideal size and scale for your organization that corresponds with the content of the work and the abilities of your managers.

돈의 의미를
이해하라

Understand
the meaning
of money

'정말 좋은 사람이다'라는 말은 한국에서는 미덕일지 몰라도 해외 비즈니스에서는 비아냥거리는 말이다. 외국에서는 '비즈니스=돈'이다. '내가 제시하는 금액=자신감의 정도'이다. 높은 견적을 제시하는 쪽이 높게 평가되는 경우도 있다. 반대로 무상으로 디자인을 제안하는 일은 '먹튀'를 허용하는 것이나 다름없다. 음식점에서 '맛이 있으면 돈을 낼게요'라고 말할 수 있는가. 모든 상황을 용납하고 전략적으로, 각오를 다진 후라면 상관없지만 말이다.

お金の意味を理解しよう

"Koreans are very nice." Even if it's a virtue in Korea, it is a contemptuous saying in international business situations. Overseas, business equals money. Your offering price shows your degree of confidence. Sometimes a more expensive offer is more highly-regarded. Meanwhile, proposing a design for free is like forgiving a person who eats and runs. Would you be able to say at a restaurant, "I'll only pay if the food is the best-tasting"? With this in mind, it is OK to respond strategically.

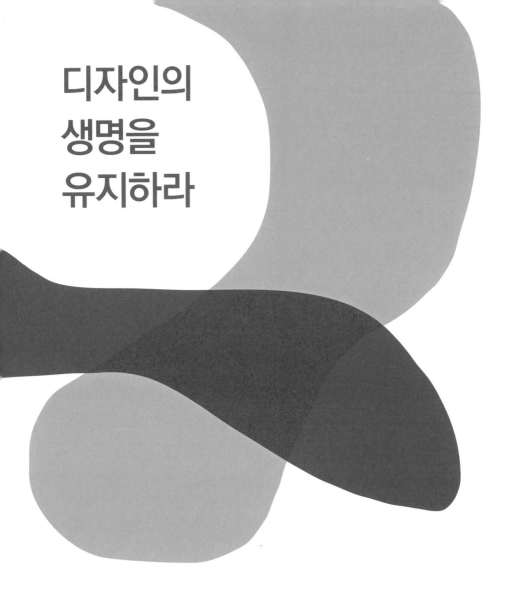

디자인의
생명을
유지하라

Keep making food use
of that design

일단 디자이너의 손을 떠난 디자인은 컨트롤할 수 없다. 하지만 디자인이 과거의 물건이 될지, 생명을 유지할지 또한 디자이너의 손에 달려 있다. 살아서 빛을 발하기 위해서는 유지, 보수와 홍보가 필요하다. 디자인은 태어난 순간이 목표가 아니라 끊임없이 승부를 겨뤄야 한다는 것을 기억하라.

デザインを
生かし／活かし
LIVE　　USE

続けよう

241

Creators lose control of their design once it leaves their hands. It's entirely up to the designer whether he consigns his design to the past, or decides to continue leveraging and making use of it. There's a lot of maintenance work that needs to be done so that your design continues to shine and be of use. Making continued use of that particular work is also something that you can entrust to you PR campaign. The ultimate goal shouldn't be the point at which the work comes into existence. Don't forget that your design needs to continue to excel long after that.

긴 텀 안에서
자신의 업무를
생각하라

Take the long
view

어떠한 일이건 순간적인 판단으로 접근하지 마라. 상대방의 과거를 미래와 연결시키는 일을 하고 있다고 생각해보자. 그 의미가 크게 달라질 것이다. 불특정 다수의 사람들이 시간을 초월해 공유하게 될지도 모른다고 상상해보라. 멍하니 앉아 있을 수만은 없을 것이다.

きな時間軸のなかで
自分の仕事を考えよう

Whatever the job may be, don't think of it as one-off, transient thing. The work takes on an entirely new meaning if you look at it as an extension of the time that the other person has already invested, and something that you offer up to the future. You won't be able to just sit around idly if you imagine all those eyes watching what you do, whether now or sometime in the future.

맛있는 시간을
함께하라

Happiness
through the
stomach

직원과의 거리를 좁히고 싶다면 우선 맛있는 식사를 대접하라. 인간은 본능적으로 맛있는 밥을 사주는 사람에게 좋은 인상을 갖는다. 이때 잊어서는 안 되는 것은 식사 중에는 이야기를 잘 듣고 칭찬을 아끼지 말 것! 즉 '연애'와 마찬가지다.

胃袋
をつかめ

If you want to break the ice and bring your staff closer together, pull out all the stops and take them out for a fantastic dinner. It's only natural to have a good impression of someone who lavished all that good food on you. And don't forget to listen to all their little stories and gossip and shower praise on them—just like you'd do with your lover, basically.

출판의 힘을
빌려라

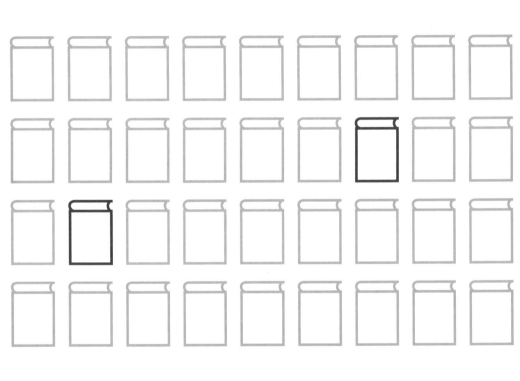

**Use the power of print
to get to the next level**

유명 디자이너 중에는 활동 초기에 책을 내거나 잡지에 소개되어 유명
해지는 경우가 많다. 디자인은 눈에 띄지 않는 작업이기 쉽다. 출판을
이용해 세상의 신뢰를 얻어라. 출판사와 친해지는 일은 디자이너에게
커다란 힘이 된다.

出肥物の力で
次のステージへ進もう

Almost all the designers who went on to become famous published
books early on in their careers and were featured in top magazines —
which then helped them to win even more recognition. The actual work
of design tends to be fairly low-key, so you should turn to paper media
to chase the glory you've been looking for, and win some measure of
trust and respect from the public. Getting friendly with publishers will
give designers that extra edge.

일은 취미가 아니다

**Don't make your
work your hobby**

"저의 취미는 일입니다!"라고 말하는 직원이 있다면 당장 함께 일하는 것을 멈춰라. 물론 그 직원을 고용한 경영자도 마찬가지! 본래 취미란 여유 시간이 생겼을 때 하는 것으로, 다시 말해 도락道樂을 의미한다. 취미가 일이라면 '다음에 휴가를 받으면 일을 해야지!'라는 마음가짐이라는 말인데, 취미로 일하는 직원과 어떻게 함께 일할 수 있겠는가.

仕事を 趣味 にしない

If any of your staff tells you that their hobby is their work — off with their head! The manager who hired the guy ought to be done away with, too. A hobby is something you enjoy at leisure during your down time, for recreation or amusement. "The next time I get a free moment, I'm going to get some work done!" being made to slog away for fun is simply inexcusable.

예상치 못한
시간을
유용하게!

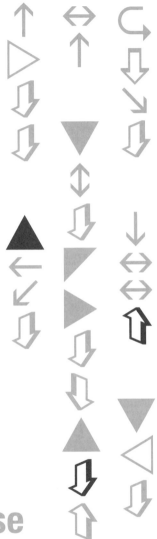

**Make good use
of unexpected
free time**

한가한 시기에 시간을 어떻게 보내느냐가 중요하다. 작업이 많아 바쁘게 처리하는 것은 누구나 할 수 있다. 오랫동안 일을 계속하기 위한 중요한 포인트는 일이 끊겼을 때, 그 시간을 어떻게 극복하느냐에 달려 있다.

思いがけず

あいた

時間

を有効に

活用しよう

Be careful how you allocate your time when you're not that busy. Anyone can attend frantically to a heavy workload when the going gets tough. What you really need to know in order to carry on working over the long haul in how to get through those times when the work just completely dries up.

중압감을

기쁨으로
전환하라

Convert
pressure to
pleasure

디자인은 결코 중압감에서 자유로울 수 없는 숙명을 가진 업業이다. 자기 자신조차 무엇이 답인지 모르는 상황에서, 기한이 정해진 일을 해내야 하니 말이다. 디자인으로 생계를 꾸려갈 생각이라면 중압감을 기쁨으로 바꾸는 기술을 익힐 수밖에 없다. 중압감은 기대감의 다른 의미. 기대받지 못하는 것보다는 기대받는 것이 좋지 않은가? 어떻게 해서든 상대방을 기쁘게 하고 싶다는 생각을 하게 된다면 디자이너로서 합격이다.

プレッシャーを"喜び"に変えよう

Design work is destined to produce constant pressure, since you get a work offer with a deadline but you don't have an answer. To make a living by designing, you must learn techniques to convert the agony of pressure into pleasure. Pressure is the flip side of the client's expectations. Isn't it better to have high expectations for you than to not? When you can think of how to provide pleasure, you care a full-fledged designer.

긍정적 전제는
작업의 원동력

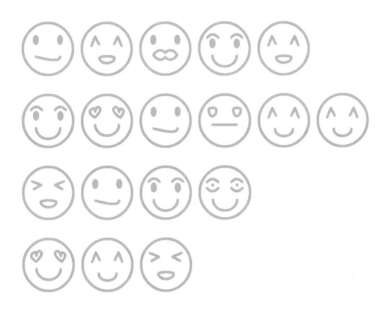

**Turn your optimism into
a motivating force**

일의 전제가 긍정적인 시작이라면 좋겠다. 결혼식, 돌잔치, 여행 기념 등 사진은 기쁜 일과 연결되어 있다. 이것은 건축 사진에서도 마찬가지로, 아름다운 것을 영원히 아름답게 남기고 싶다는 긍정적인 전제에서 시작된다. 다만 건축 사진은 현재를 공유하면서 동시에 건축물의 미래의 얼굴로 작용한다는 주의사항을 내포하고 있다는 사실을 간과해서는 안 된다.

前向きさ を引き継いで
仕事の 原動力 としよう

The premise of your work is that these photos will be the start of something big. We associate photographs with happy events and occasions, like weddings and vacations. The same is true of architectural photography — it exists because we want to create an aesthetically pleasing record of these beautiful buildings for posterity. Although your work serves to share this particular moment with other people, you also need to be aware of the slightly frightening fact that these images are going to become a future document of these architectural works.

상상력을 발휘하라

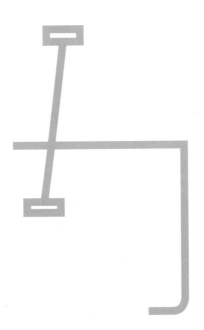

Fire up your imagination

해외에서 메일 한 통으로 작업이나 콜라보레이션 의뢰가 오는 일이 흔해진 시대다. 전화나 메일만으로 일을 시작하고 끝내기도 한다. 서로 영어가 모국어가 아닐 때는 답답하기도, 안타깝기도 하다. 하지만 여기서 포기한다면 그것으로 끝이다. 순간 이동이라도 하듯 상대방의 입장에서 생각해보라. 상상력을 총동원해 뉘앙스를 읽는다면 전 세계인과 교류하는 일도 어렵지 않다.

想像

力

を働かせよう

These days, it's not uncommon for an email from a foreign client to suddenly appear in your inbox with an offer of work or a proposal to collaborate. Projects can get off the ground or shelved just through the telephone or email. It can be an utterly frustrating experience when misunderstandings occur among people whose first language is not English — but once you give up, that's the end of the story. Try putting yourself in the other person's shoes and thinking about things from their point of view — just as if you'd teleported yourself next to them. Fire up your imagination and decode those nuances, and you'll find that it's not such a stretch to communicate with people from all over the world.

디자인 그 이상을
디자인하라

**Design something
other than the product
itself**

아무리 훌륭한 성과를 냈다 해도 고객은 그 과정이나 당신의 됨됨이에
도 주목하고 있다는 사실을 잊지 마라. 좋은 성과는 당연한 것. 성과
가 같다면 무엇에 차이를 두겠는가? 차이를 디자인할 수 있을 때만이
진정한 디자이너라 할 수 있다.

デザイン
以外を
デザイン
しよう

No matter how great a job you manage to do, never forget that your
clients have their eyes on the entire process, and your own personality.
Clients expect great results as a bare minimum. If the end product
is the same, what's going to make the difference? Only when you
manage to "design" these other aspects of your practice can you call
yourself a real designer.

낡지 않는
것에서
새로움을
찾아내라

Discover
newness
in things that
don't get old

새로움을 만들어낼 수 있다는 것은 다른 사람이 알아차리지 못한 일을 먼저 감지하거나 세상에 없는 것을 예견하거나 가정하는 능력이 있기 때문이다. 남다른, 새로운 무엇을 찾아내려는 행위는 디자인 본래의 가치가 아니다. 이 일에 필요 이상의 강박관념을 가져서는 안 된다. 새로움은 눈앞에 수없이 많이 존재하는 것을 어떻게 조합하느냐에 따라 얼마든지 만들어낼 수 있다. 오래 되었지만 세월을 느끼지 않게 하는 것, 그것이 바로 유일한 새로운 디자인이다.

Being able to produce something new is really about the ability to realize quickly what others haven't, to foresee things that haven't appeared yet, or to have a certain hypothetical, imaginative vision. Discovering something new and original that is different from everything else out there is not what design is good for, so you shouldn't obsess over that more than necessary. There are lots of new, fresh things are right there in front of you. All the originality and newness you want are yours for the taking, as long as you combine these things in the right way. Things that don't get old are the only "new designs" there are.

정보는 한눈에 쏙

Make information clear

당신에 대해 알고 싶은 사람은 무엇보다도 알기 쉬운 정보를 원한다. 멋진 웹사이트나 어려운 개념을 늘어놓은 포트폴리오를 만들 필요는 없다. 간결한 메시지, 알아보기 쉬운 표지, 그리고 업데이트를 게을리 하지 않는 것만으로도 당신에 대한 홍보는 충분하다.

じょうほう　　　　くりあ
情報はクリアであれ

People who want to know more about you are looking for information that's easy to understand, more than anything else. You don't need a fancy website or portfolio with a complex concept in tow. What matters is a simple, concise message and clear-cut presentation. Just by not being lazy with updates, your firm is going to get a solid PR boost.

얼굴을 맞대고 일하라

Face time is important

상대방과 얼굴을 마주하게 되면 공적으로 만난 이가 한 사람의 개인으로 다가온다. 상대방의 개성을 알게 되면 일이 일 이상으로 느껴지고, 그의 일을 자신의 일로 받아들일 수 있게 된다.

顔を見せ合う
仕事をしよう

You learn to appreciate your clients and colleagues as individuals interacting with them face to face. When you get a glimpse of what it is that makes people unique, work will stop being just work, and other people's work will become something personal to you, too.

스케줄을 지켜라

Start Time limit Delivery

Keep to the schedule

시간을 들이면 보다 좋은 물건, 좋은 디자인이 나온다. 정말 그럴까? 주문을 받아 물건을 만들거나 디자인하는 경우는 반드시 주문한 사람이 존재한다. 그 주문자는 판매 시기를 고려하여 판매 계획을 세웠을 것이고, 거기에 맞춰 주문했을 것이다. 주문자의 입장을 생각한다면 시간을 지키는 일, 시간 내에 물건을 만드는 일이 얼마나 중요한지 더 이상 설명할 필요가 없을 것이다.

Start Time limit Delivery

時 間 を 寸 ろ う

Spending more time will lead you to a better end product and design. Is that really true? People who make or design things for a living necessarily work for clients or outsourcers who have undoubtedly drawn up a sales plan that takes into account when the product will hit the market. Working on schedule and producing results within the stipulated time are also important.

유명한
사람일수록
존중하라

Pay more respect
the more famous the
person is

유명한 디자이너의 이름에는 '씨'를 붙여 대화하라. 대화 중 인용할 때, 예를 들어 '안도 다다오*가 말이지…'처럼 만난 적도 없는 사람을 경칭도 없이 함부로 부르지 마라. 당신이 그렇게 행동하는 동안에는 결코 안도 다다오 씨와 겨루어 볼 수조차 없을 것이다.

*안도 다다오安藤忠雄 : 건축계의 거장이자 한계에 도전하는 게릴라 건축가. 절제와 단순미로 표상되는 일본의 아름다움을 건축물로 표현하고 있다.

呼ぼう ほど 付けで さん 著名な人

When referring to famous designers in conversation, make sure to call them "~san". Never refer simply to "Tadao Ando" or other well-known designers whom you haven't even met without using an honorific. You'll never join the same league as Ando-san as long as you refer to him like that.

좋은 질문을 만들어라

Q•••••••••••••••

A•••••••••••••

Ask great questions